Creative Techniques in Landscape Photography

Creative Techniques in Landscape Photography

Gerald Woods and John Williams

HARPER & ROW, PUBLISHERS

NEW YORK
Cambridge London
Hagerstown Mexico City
Philadelphia São Paulo
San Francisco Sydney

© Gerald Woods and John Williams 1980
First published in the United States 1980 by
Harper & Row, Publishers, Inc.,

Printed in Great Britain

Library of Congress Catalog Card Number 80–8396
ISBN 0–06–014835–7

Contents

Acknowledgments

We should like to express our gratitude to those landscape photographers who have provided us with examples of their work – Ansel Adams, John Blakemore, Gianni Berengo Gardin, Mario Giacomelli, Aart Klein, Raymond Moore, Emile van Moerkerken, Guy Ryecart, Augusto Rosso, and Denis Thorpe. Also to Jan Bons and Lia Rondelli who assisted us in contacting photographers.

Most of the line drawings and various photographs dealing with technique were produced by the following students at Derby Lonsdale College, Department of Graphic Design: Jean Julian, Haluk Gurer, Anders Lien, Ian Slater and Gina Dilley. Special thanks are due also to Keith Habibi.

We acknowledge the help given by various libraries, museums, and manufacturers in providing photographs. In particular the Humanities Research Center of the University of Texas at Austin for photograph 2 from the Gernsheim Collection; Library of Congress for nos. 12 and 13; The Victoria and Albert Museum for nos. 3, 4, 7, 8, 9, 10, 14 and 80; Brecht Einzig Ltd for no. 62; Rank Audio Visual, Hasselblad (GB) Limited, Sangamo Weston Limited, Photax Limited and Foster Associates.

We were greatly encouraged throughout by William F. Waller – Editorial Director of B.T. Batsford Ltd. Finally our thanks are due to Yvonne Woods who typed the manuscript.

Introduction

Until quite recently the photographer was not really taken seriously as a landscape artist. At best, he was seen to have relieved the painter of the task of making an exact representation of nature. Certainly photography is extremely useful for recording purposes, since a great amount of information can be registered with high speed, but it is by no means a perfect recording medium. It is not necessarily more truthful than painting (in fact, some paintings can be more accurate and, indeed, more realistic than photographs). It does not provide an exact replica of nature: the image will vary according to the viewpoint, the type of lens, the emulsion, the exposure and various other factors. However, this very mutability of image enhances the value of the camera as a creative tool. There is sufficient scope for sensitivity to make one's own special point, while allowing the photograph to retain its essential authenticity.

Delacroix was one of the first painters to recognize the value of photography; he described the Daguerreotype as a 'translator commissioned to initiate us further into the secrets of nature.' In 1931 Edward Weston noted that 'artists don't copy nature, and when they do record quite literally, the presentation is such as to arouse connotations quite apart from the subject matter. The camera recording nature exactly, can yet be used to convey an abstract idea.'

More recently the photographers of the West Coast school in America have taken the medium still further towards a more poetic vision. The late Minor White asked, 'How far can the camera go towards making manifest the invisible? That is its work, but how far can it go? How much can the camera bring to others of my own experiences of light or darkness?'

Talking about his work, the English photographer Bill Brandt says: 'To be able to take pictures of a landscape I have to become obsessed with a particular scene. Sometimes I feel that I have been to a place long ago, and must try to recapture what I remember. I wait for the right season, the right weather, and the right time of day or night, to get the picture I know to be there.'

A great deal of patience is needed for landscape photography; it is often necessary to wait and wait for just the right quality of light. Unlike the painter, the photographer cannot evaluate the gradual progression of his work. The seeing, the thinking, all the creative work must be done and all the decisions made before the shutter is released. The pressing of the button is merely a confirmation of the work which has already taken place – and then one must wait until the latent image has been processed. It is not until the first prints are made from the negative that one can begin to evaluate the decision originally taken to record a particular aspect of nature.

One of the difficulties facing the beginner is that he/she will be offered a great deal of advice – advice which will often be characterized by dogma and personal prejudice. All sorts of expensive equipment will be advocated, or conversely, in an equally silly generalization, all such apparatus will be dismissed as mere gadgetry. We have tried to present the reader with as much technical information as we feel is necessary to take landscape photographs with a degree of competence. Additionally, the sections of the book that deal with aspects of perception, composition and the nature of landscape should help to induce a truly creative approach to the subject. Finally, the folio of landscape photographs taken by eminent photographers in Europe and in the USA should provide sufficient stimulus for even the most dormant talent!

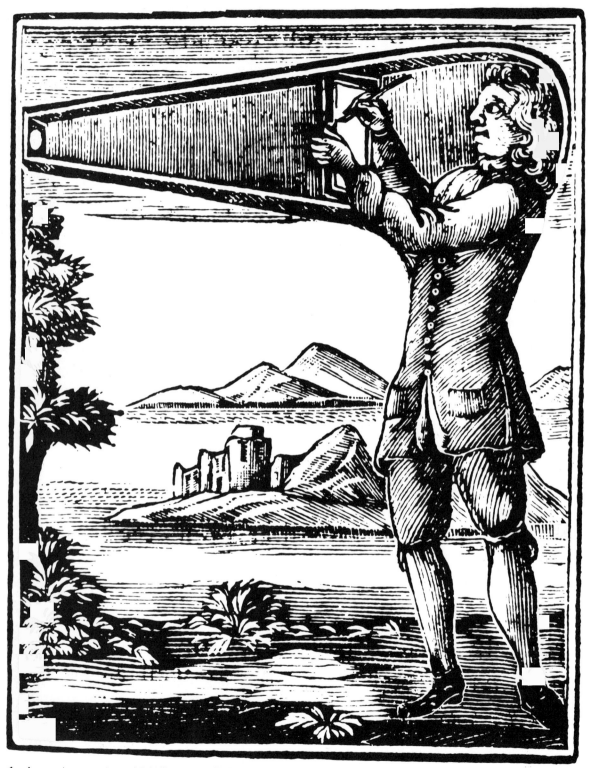

1 A wood engraving which illustrates Robert Hooke's camera obscura.

1 Historical Survey

Contemporary photographic technique has become increasingly dependent on high technology and sophisticated gadgetry. In some ways, however, our interest in purely technical matters has led to our detachment from essential photographic values. Landscape will yield its secrets to the perceptive photographer, rather than to one who is merely technically competent. Early photographers were much more aware of the way that light radiating from the sun defined the three-dimensional solidity of objects in landscape, and separated one plane from another as they receded in distance. It is interesting therefore to consider briefly the period of prehistory which led to the discovery of photography, and the subsequent events which led to our present state of development.

'DRAWING WITH THE SUN'

The Arabian scholar Alhazen (A.D. 965–1038) records the use of the camera obscura as a device for observing the eclipse of the sun. Without such a device, it was found that intense observation of the sun soon led to impaired vision and eventually to blindness. John Peckham, Archbishop of Canterbury, and a contemporary of Roger Bacon, records in his paper 'Perspectiva Communis' (1279), how people were dazzled for two or three days after direct observation of the sun. He also describes the working of a camera obscura: 'one should make in the roof of a house, or in a window, an opening towards that part of the sky where the eclipse of the sun will appear, and the size of the hole should be about the same as that made in a barrel for the purpose of drawing off wine. Opposite the light of the sun entering through this opening should be placed, at a distance of twenty or thirty feet, something flat, for instance a screen. A ray of light will then be seen delineating itself on the screen in a round shape, even if the aperture is angular. The illuminated spot will be bigger than the opening, the larger, in fact, the further the screen is moved away from it, but then the image will be more feeble than if the screen is placed closer.'

Leonardo Da Vinci (1452–1519) makes reference in his notebooks to the construction of a camera obscura, noting how the image of an illuminated object passed through a small hole in a darkened room could be projected on to paper. It was Giovanni Battista Porta (1538–1615) however, who is first credited with the use of the camera obscura as an aid to drawing: 'If you cannot paint, you can by this arrangement draw [an outline of the image] with a pencil. You have then only to lay on the colours.' Porta went on to perfect a camera obscura which was fitted with a convex lens in the aperture, the image was received through the lens on to a concave mirror, thus enabling the image to appear the right way round.

The camera obscura was in general use until the late eighteenth century; all kinds of sophisticated portable models were designed, including an ingenious sedan chair specially converted with a lens fixed in the roof so that the image was reflected on to a drawing table by a mirror. Such an invention clearly anticipated the arrival of landscape photography. An Englishman, Robert Hooke (1635–1703), developed a portable camera specially designed for landscape drawing. The camera was fitted on a stand with a ball-and-socket joint so that it could be rotated to obtain different viewpoints. An illustration, which accompanied Hooke's paper delivered to the Royal Society, shows the artist with his head inside the camera, tracing the image on the transparent paper backing.

Perhaps the finest use of the camera obscura, or camera lucida as it was later known, is Vermeer's 'View of Delft.' Kenneth Clark in his book, *Landscape into Art*, says that 'this unique work is certainly the nearest which painting has ever come to a coloured photograph.'

It was a constant source of frustration to inventors and scientists that no way could be found of permanently fixing the fleeting, transient images received by the camera obscura. During the eighteenth century, this single problem was the basis for experiments carried out by scientists all over Europe. Scores of scientific papers were published, all containing variations of chemical formulae dealing with the effect of light on silver salts. It was a Swedish chemist, Carl Wilhelm Scheele (1742–86), who discovered that violet rays are chemically the most active. He found that by laying a ground of powdered chloride of silver on paper, and allowing the spectrum of the sun's rays to fall directly onto the powder, the violet part of the spectrum had a tendency to blacken far more rapidly than other rays within the colour spectrum. Following Scheele's discovery, another chemist, J.W. Ritter (1776–1810), using a test-strip of white paper covered with a ground of silver chloride, deduced that the process of darkening went beyond those violet rays which were visible. He concluded that the unseen, or ultra-violet rays, were chemically more powerful than those rays which were visible.

This phase in the prehistory of photography is particularly important: scientists had become aware that in the presence of certain kinds of light, salts of silver of chloride undergo change. They further understood that this change may be visible to the eye, as in the case of the darkening of chloride of silver, or that the invisible process of darkening beyond the luminous rays of light could at least be ascertained by the reaction of the silver salt to certain chemicals.

Those coloured rays (visible or invisible) which will effect a change are known as actnic. The range of colours in the spectrum which were found to be most actnic are: violet, indigo, blue and green. (It is because red and yellow rays of light are non-actnic that we are able to work in a darkroom with a red safelight.)

THE BIRTH OF PHOTOGRAPHY

The brothers Joseph Nicéphore and Claude Niépce are generally credited with the first successful attempt to retain by chemical means the images produced by the camera obscura. It was Thomas Wedgwood (1771–1805), however, who laid the foundations for their discovery. Thomas was the fourth and youngest son of the English potter Josiah Wedgwood. The camera obscura was sometimes used as an aid to drawing the stately homes of England which were engraved on copper and the prints transferred to pottery as a decorative feature. Most of Wedgwood's experiments were published by his friend Sir Humphry Davy, who delivered a paper to the Royal Society. Wedgwood was unsuccessful in his attempt to permanently fix the images produced by the camera obscura. What he did manage to do was to produce what we now call 'photograms.' The art of 'nature printing' was a popular pastime in England; natural forms such as ferns and leaves from various plants were smoked black with a lighted wax-taper, and pressed onto paper, depositing a sooty image. Wedgwood found that the properties of leather (gallic acid in tannin), when covered with a ground of nitrate of silver, were more receptive to light than paper. Wedgwood began to make his own nature prints, using white leather coated with silver nitrate. He observed that those parts of the leather which were concealed by the objects placed on the surface (leaves, grasses etc.) remained white, whilst the remaining parts of the chemically treated leather gradually turned dark. What he failed to do was to find a suitable fixing agent to prevent the entire surface of the leather eventually turning black.

In the early part of the nineteenth century, the chemical process of printing known as lithography had captured the imagination of artists. The process of lithography is based on the natural affinity of grease to calcareous limestone, and the mutual repulsion of grease and water. The Niépce brothers were much attracted by the idea of a printing process founded on chemical rather than mechanical principles. Nicéphore's son, Isidore, made drawings directly onto stone, while his father carried out all the processing and printing. The limestone used for lithography proved to be costly, since it was quarried in Bavaria and exported to France; therefore they continued their experiments using pewter plate instead of stone. Though Nicéphore's ability as a draughtsman did not equal his expectations, his main objective was to produce a printing plate. He made several attempts to transfer engravings onto pewter plate coated with a light-sensitive ground. The paper used for proofing the engraving was oiled to make it transparent, it was then placed in close contact with the plate, and exposed to strong sunlight for several hours. The resulting images were not particularly rewarding: either the paper was not transparent enough to allow the light to filter through onto the plate, or the light-sensitive coating on the plate was unsatisfactory.

Undeterred by his failure to produce a printing plate, Nicéphore continued to experiment with the idea of harnessing sunlight to make permanent images from natural forms. He had come to terms with his inability to delineate nature by the more conventional skills of drawing, and went on to develop a process which he later called heliography – sun drawing.

He ordered three cameras of different sizes from a local carpenter, and in his workroom at Gras, made his first print. Paper that was coated with chloride of silver was used to retain the image which filtered through the aperture of the camera. The image produced was a negative, but nevertheless it was made with a camera. Encouraged by his success, Nicéphore made another series of prints, and managed to sharpen the image by inserting a simple diaphragm made from cardboard in front of the lens. He was also able to partially fix the image using a solution of nitric acid. When sending the prints to his brother Claude he warned that the action of the acid would eventually bleach out the image entirely.

During all the time of these experiments, his primary objective was still to produce a satisfactory printing plate, but though he continued in this direction for several years, he never really achieved that end. In 1822, however, he produced his first heliograph plate, which was an engraving of Pope Pius VII, transferred by light to a plate coated with a ground of bitumen of judea. Nicéphore had combined his knowledge of the principles of lithography with his earlier experience of producing prints on a paper sensitized with silver chloride. Dilute bitumen, or asphaltum, is used in lithography to make the printing image permanent. Nicéphore discovered that when a plate was given a coating of asphaltum, it hardened in sunlight, whereas those parts of the plate that were shielded from direct light remained liquid. Once again he experimented with an engraving placed in close contact with a plate – the paper on which the engraving was printed was oiled to make it transparent, and the plate coated with a ground of bitumen of judea dissolved in Dippel's oil. The plate was then given a long exposure in direct sunlight. The printed lines of the engraving prevented the light source from hardening the coating on the plate, while the transparent areas of the print allowed the light through and so harden the bitumen. The plate was then washed carefully in a solvent and given a light etch in nitric acid. The plates were then proofed by a Parisian engraver,

Augustin François. In effect Nicéphore had discovered the basis for photo-lithography, which had been his main objective, though the prints were of very poor quality.

THE FIRST LANDSCAPE PHOTOGRAPH
Nicéphore Niépce's greatest ambition was to render a permanent image of nature by his method of sun printing. He achieved this ambition more or less at the same time that he produced his first heliograph plates from engravings – the landscape view was that seen from his workshop window. He used a small camera with a lens taken from his solar microscope, and, in a letter to his brother Claude, he describes what took place: 'I placed the apparatus in the room where I work, facing the birdhouse and the open casement. I made the experiment according to the process which you know and I saw on the white paper all that part of the birdhouse which is seen from the window and a faint image of the casement which was less illuminated than the exterior objects.' The image (now mottled with age), is preserved in the Gernsheim Collection at the University of Texas. One can still make out the main forms of the composition – buildings on the left and right receding in perspective towards the horizon. On the left, the foliage of a tree is barely decipherable, and beyond, an imperceptible haze. The light is not concentrated in one part of the photograph; this is due to the fact that the sun had shifted considerably during the long hours of exposure, so that buildings on both sides of the courtyard appear to be in direct sunlight. There were no half-tones registered on the print, only the strongly contrasting areas of light and deep shadow.

Congratulating his brother on his success, Claude wrote to Nicéphore: 'The engraving of views from nature is still more magical than the other [he refers here to the heliograph plates made from engravings], which is far from being only a knick-knack, as you like to call it; but it is one of the most useful and most brilliant discoveries of the century, as I am sure, and I desire with all my heart that it will be infinitely productive.'

In 1827 Nicéphore Niépce went to England to visit his brother Claude who was seriously ill. Whilst in London he was persuaded by his friend Francis Bauer, a botanist at Kew, to address the Royal Society on the subject of heliography. He aroused little enthusiasm for his work, however, and returned to France in January 1828 bitterly

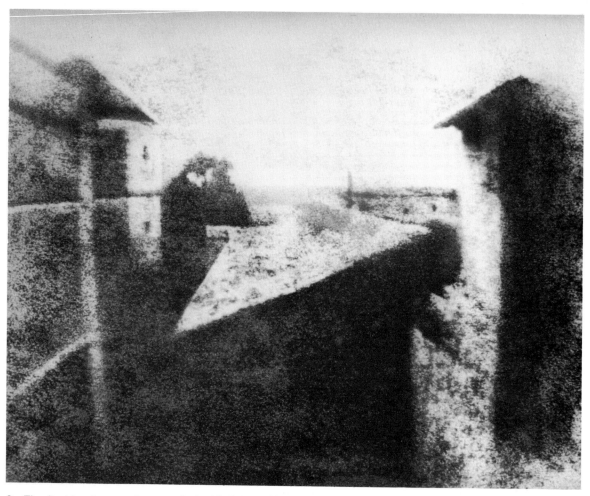

2 The first landscape photograph, by Nicéphore Niépce, taken at Chalon-sur-Saône, France, on polished pewter plate. On the back of the photograph is written 'The first result obtained spontaneously by the action of light.' The exposure was approximately 8 hours, which explains the even distribution of light.

disappointed. It was at this time that he made contact with Louis Jacques Mande Daguerre, a painter who specialized in producing stage sets. Daguerre was also the joint proprietor of a diorama theatre specially constructed to house vast panoramic sets which were drawn with the aid of a camera obscura, to give heightened realism to illusory effects. He used lighting techniques for greater effect, and the auditorium which was circular could be rotated to give different viewpoints.

Daguerre approached Niépce with the idea of forming a partnership in the hope that they might mutually benefit from each other's achievements. Niépce was disinclined to come to any sort of agreement, but realized that, if he were to make further progress with his prints from nature, he would need better cameras and lenses. Although Daguerre did not have much to contribute from a theoretical standpoint, he did have a camera which was far more advanced technically than the primitive cameras so far used by Niépce. Largely because of this, Niépce entered somewhat unenthusiastically into a partnership with Daguerre, initially for a ten-year period. The partnership was short-lived however; Nicéphore Niépce died at his home in Chalon-sur-Saône, only four years after the agreement had been signed.

Though he inherited the fruits of Niépce's years of painstaking research, Daguerre had not himself produced a single image by the heliographic process. In 1831, he accidentally discovered a

method of developing the latent image. Most of the experiments he had carried out using Niépce's recipes were unsatisfactory, and the sensitized trial plates which had been exposed to light were stored in a cupboard in his studio. It was on one of these plates that he noticed an image which had formed several days after the period of exposure. After examining all the possible causal factors, he eventually discovered that the vapour of mercury from a broken thermometer in the cupboard had 'brought out' the image. The immediate significance of this discovery was that the exposure time could be shortened considerably to 20 or 30 minutes, instead of eight hours or so in direct sunlight. The latent image could then be developed in the studio by mercury vapour. Daguerre was much encouraged by this achievement, and thereafter insisted that his name should have precedence in the partnership. It was an arrangement that Isidore Niépce (Nicéphore's son) agreed to reluctantly. Several years later Daguerre finally perfected a method of fixing the image by using a solution of common salt immersed in hot water.

Daguerre, always a showman and an experienced entrepreneur, discarded the title 'Heliotype,' and immortalized himself by renaming his invention the 'Daguerreotype.' He was now anxious to market the process, since unlike Niépce, he was seeking some financial return, rather than being content simply to produce images for the sheer joy of it. In order to market his ideas he needed further financial investment, and he tried to boost his funds by public subscription. Most French businessmen, however, were still very sceptical about the invention and he was unable to raise sufficient capital. It was shortly after he had demonstrated the Daguerreotype to François Arago, who was a notable astronomer of the day and a member of the Chamber of Deputies, that he at last gained the sort of patronage he needed. Arago was much impressed by the Daguerreotype process and immediately introduced a bill into both houses of the government, which recommended that the invention should be purchased by the government for the benefit of the nation and the free world. As a result, both Daguerre and Isidore Niépce received a substantial pension for life for their efforts. Additionally, Daguerre was awarded the Legion of Honour.

Arago continued to promote the invention widely by a series of forceful lectures. Talking about the potential of the Daguerreotype he said –

'It requires no knowledge of drawing, and does not depend upon any manual dexterity. By observing a few simple directions, anyone may succeed with the same certainty and perform as well as the author of the invention.' On first seeing a Daguerreotype, Paul Delaroche was so amazed, he declared: 'From today painting is dead!'

Daguerre published a manual of technique which ran into numerous editions and was translated into at least eight languages. He gave weekly demonstrations of the process at the Conservatoire des Arts et Métiers. The procedure for these demonstrations was as follows. First a silver-faced copper plate was carefully polished with fine pumice powder and oil. This action tended to dull the surface of the plate. Then the plate was sensitized by immersion in a bath of nitric acid diluted with distilled water. After warming the plate slightly, it was given a coating of iodine by exposing the plate to the vapour in a specially constructed box. When removed from the vapour box, the plate had a smooth layer of iodide of silver. It was then placed within range of the camera obscura and the image focussed directly onto the surface. The exposure varied according to the intensity of the light outside, but usually ranged from ten to 40 minutes. Nothing was seen on the plate after exposure until it had been placed in a box containing vapour of mercury. The development of the latent image was then achieved rapidly and fixed with hyposulphite of soda. Finally the plate was washed in distilled water and dried by the heat of a lamp.

It is difficult for us to fully appreciate the impact that the Daguerreotype had on contemporary society in the mid-nineteenth century; the fact that nature could be seen to delineate itself in a seemingly magical way on a metal plate was to many people profoundly disturbing. It was especially worrying for portrait painters and landscape artists who feared for their livelihood.

Publishers were quick to realize the potential of the Daguerreotype; at that time there was no known method of photo-mechanical reproduction, though Niépce had clearly anticipated the advent of photo-lithography. Daguerreotypes provided a useful source of reference for reproduction engravers and lithographers, using autographic techniques. In Paris the optician Lerebours sent teams of people, trained in the manipulation of the Daguerreotype process, to record the great monuments and sights of antiquity. Horace Vernet, a painter, was commissioned by Lerebours

to make Daguerreotypes of the great pyramids, whilst his colleague, a certain Lotbrinière, went on to Greece. Many other similar travels were undertaken, and the Daguerreotype brought home to the man in the street the full realization of places abroad which hitherto he was aware of only through verbal description and reproductive engravings, several times removed from reality.

Experiments with portraiture were less successful, mainly due to the problems of lighting, and the necessity for the sitter to remain in position without moving for long periods of exposure. These problems were soon to be overcome by refinements to the process: the introduction of better quality lenses from Germany, and a more sensitive method of preparing the plates using bromine in addition to iodine, and the fact that exposure time could be reduced to a few minutes' duration. Studios for portraiture were flourishing in most major cities in Europe and in the USA.

WILLIAM HENRY FOX TALBOT

Fox Talbot was elected a Fellow of the Royal Society in London in 1831, for his attainment in the field of mathematics. Five years earlier he had bought Lacock Abbey in Wiltshire and represented Chippenham as a Liberal Member of Parliament. He very soon became disillusioned with politics, and in the autumn of 1833 went on holiday with his wife to Lake Como in Italy, taking with him a small camera lucida manufactured by Wollaston. Even with this aid to drawing from nature, he did not manage to produce much more than a limp outline traced on paper. He realized that the mere tracing of an image onto paper was unsatisfactory and resulted in a drawing which lacked conviction. He was aware that one needed a better grasp of draughtsmanship which could only be gained with skill and much practice. Later he recalled his feelings on that occasion: 'The inimitable beauty of Nature's painting which the glass lens of the camera throws upon the paper in its focus – fairy pictures, creations of a moment, and destined as rapidly to fade away. It was during these thoughts that the idea occurred to me – how charming it would be if it were possible to cause these natural images to imprint themselves durably and remain fixed upon the paper!'

He was aware of the already common theory of the sensitivity of nitrate of silver to light, but at that time was unaware of the work that had been carried out by Niépce and Daguerre. In fact it was

3 *Right:* 'The Open Door,' Lacock Abbey, by William Henry Fox Talbot, 1844. The detail in this photograph is remarkably fine considering it was made from a semi-opaque paper negative.

not until 1839 that he first heard Arago lecture on the Daguerreotype process at the Academy of Sciences in London.

On his return to Lacock Abbey in 1834, Fox Talbot began experiments with hand-made paper, coated with a solution of sodium chloride (common salt), and then, after drying the solution, he further coated the paper with silver nitrate. He was generally disappointed with the first results which he obtained after long hours of exposure in sunlight. Removing the paper from the exposure frame, he noticed that the edges of the print had a tendency to darken more rapidly than other areas. From this he deduced that a weaker solution of the sodium chloride could conceivably reduce the exposure time. Further experiments proved the theory correct; using a weak solution of sodium chloride, followed by a normal coating of silver nitrate, he found that the darkening of the image accelerated so rapidly that a strong fixing agent of salt water had to be used.

He had a number of miniature cameras made by a local carpenter, which were fitted with lenses from his microscopes and which produced an image 1-inch square. He then took a series of photographs of Lacock Abbey and of various plants found in the grounds; the images at this stage were all negative and on paper. Arago's lecture on the Daguerreotype process came as something of a shock to Fox Talbot, who had thought of himself as being the sole inventor of the process by which images from nature could be fixed. The element of competition, however, prompted him to work with a greater sense of purpose, and shortly after Arago's visit to London, he exhibited his 'photogenic drawings' in the library of the Royal Institution. These consisted mainly of nature studies – flowers, leaves, insects and the like, taken with the microscopic lens. Also included were views of Lacock Abbey.

In his paper, 'Some Account of the Art of Photographic Drawing,' delivered to the Royal Society, Fox Talbot described the negative/positive process which we now accept as the cornerstone of the photographic process. After describing how the image is fixed on paper, he goes on to suggest how the negative image can itself be used to produce a positive image when placed in contact with a

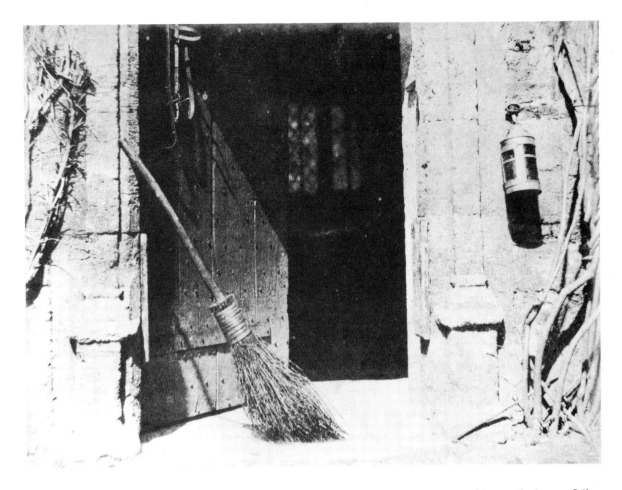

second sheet of sensitized paper and given a longer exposure. Unlike Niépce, he did not think of oiling the paper to make it more transparent, and the resulting positive image was therefore rather hazy due to the opacity of the paper and the interference of the grain. Speaking of his negative/positive process, Fox Talbot said – 'In this way we have to contend with the imperfection arising from two processes instead of one, but I believe this will be found merely a difficulty of manipulation. I propose to employ this for the purpose more particularly of multiplying at small expense copies of rare or unique engravings.' His contemporaries failed to recognize the full potential of the negative/positive process; as far as they were concerned, the images produced by the Daguerreotype process were infinitely superior to the barely discernible images resulting from Fox Talbot's process.

Feeling that his work had not been given the recognition and acclaim he rightly deserved, Fox Talbot took care to patent his invention and every subsequent development of his techniques. Like Daguerre, he discovered by chance a means of developing the latent image – in his case it happened when some of the pre-sensitized paper he had been using did not produce a particularly strong image. He decided to re-sensitize the paper, and in doing so, found that as he coated the paper with a solution of gallo-nitrate of silver (an improved solution with gallic acid), the latent image from the initial exposure became fully developed.

In 1844, Fox Talbot published the first of a series of books under the title *The Pencil of Nature*, being in fact the first books ever published using photographs as illustrations. In a preface to the work, he says – 'The plates in the present work are impressed by the agency of light alone, without any aid whatever from the artist's pencil. They are the sun pictures themselves, and not, as some persons have imagined, engravings in imitation.' While the work was produced 'without the aid of the artist's pencil,' they were not produced with-

out the aid of an artist's trained eye. Talbot in fact employed a painter, Benjamin Turner, to take the photographs for the books. He acknowledged the need for sound visual judgement – 'A painter's eye will often be arrested where ordinary people see nothing remarkable. A casual gleam of sunshine, or a shadow thrown across his path, a time-withered oak, or a moss-covered stone may awaken a train of thoughts and feelings, and picturesque imaginings.' Although most of the photographs taken for the book were rather mundane studies of architecture and still-life arrangements, a few at least were beautifully composed, and demonstrated some feeling for the qualities of light.

Photographs printed on paper were not generally very popular. This was due mainly to the fact that the Daguerreotype, with its sharper detail and more subtle tones backed by the silvery surface of the metal plate, became a kind of semi-precious object, which people wanted to possess. Fox Talbot spent much time demonstrating his techniques in England and in Paris, but he always worked in the shadow of the Daguerreotype process, which was by this time widely accepted and used throughout Europe. He became increasingly bitter about the lack of recognition which he felt was due to him, and as a reaction to this, he guarded the patents on his work, taking legal action against anyone who encroached on any aspect of his published formulae.

Following the world-wide acclaim for the work of Daguerre, and to a lesser extent the work of Fox Talbot, there were a number of other individuals who contributed to the advancement of photographic technique. In a brief survey such as this, one can only touch upon some of the more notable achievements.

FURTHER CONTRIBUTIONS

Sir John Herschel, the English astronomer and scientist, contributed much to the improved method of fixing the image. He discovered that the most effective means of arresting development was to use hyposulphite of soda. Both Daguerre and Fox Talbot used Herschel's methods. We are also indebted to Herschel for formulating photographic theory. He defined the main prerequisites for producing a successful photographic image as being very susceptible paper, a perfect camera, and the means of arresting further action. The terms 'negative' and 'positive,' and even the word 'photography,' were brought into general usage in the work published by Herschel.

The Rev. Joseph Reade was an astronomer with a keen interest in Fox Talbot's work. Reade was primarily interested in using photography as a vehicle for reproducing the enlarged fragments of animal and plant life that were visible through the lens of his microscope. He called his prints 'solar mezzotints,' probably because the print quality resembled the gritty texture of hand-engraved mezzotint prints. He used the lens of his solar microscope and, like Fox Talbot, sensitized his paper with common salt and nitrate of silver. Reade is credited with the discovery that gallic-acid added to nitrate of silver accelerates the development of the latent image. He also successfully put into practice Herschel's theory of using hyposulphite of soda as a fixing agent.

The popularity of the Daguerreotype in France produced a climate conducive to further experiment. Hippolyte Bayard made positive images on paper directly from the camera after an hour-long exposure. It was Blanquart-Evrard, however, who modified the process sufficiently to reduce the exposure time by a quarter. He opened a photographic 'factory' in Lille, which specialized in producing hundreds of photographs for books. He is perhaps best known for the beautiful grey tones he achieved in his prints, which were made by acidifying the hyposulphite fixing bath. Though he was basically making use of Fox Talbot's methods, the difference was mainly in the preparation of the printing paper. Blanquart-Evrard ensured that the fibre of the paper was completely impregnated by immersion first in a bath of iodide of potassium, and then in a bath of silver salts. Although slight, this difference in preparation produced finer detail, and a much wider range of gradated tones. He later conceived the notion of using albumen (egg white) and whey as a ground on paper which was receptive to a layer of silver salts. This mean that the paper could be used 'dry,' and did away with the messy procedure for preparing paper for the conventional collotype process (which uses dampened gelatine).

Another variation on the collotype process was the 'waxed-paper' method, devised by the painter Gustave Le Gray. Collotype negatives were usually given a coating of wax to make them more transparent, but Le Gray found that by using a much thinner paper, and by applying a fine, even coating of wax, much greater transparency could be obtained. This meant that more light could filter through the negative and produce more half-tones and finer definition.

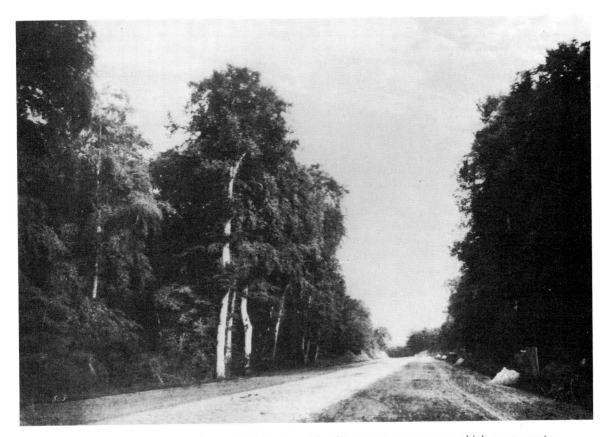

4 'Forest Scene,' by Gustave Le Gray, 1856. Produced by the wax-paper process which gave greater transparency to the negative, and consequently finer detail than the process employed by Fox Talbot.

In Germany a number of scientists were working concurrently with the ideas which had preoccupied the pioneers of photography in France and England. Franz Von Kobell was successful in producing a series of 'light drawings' from nature. Von Kobell observed that some subjects in nature were more suitable for the medium than others – 'Trees, meadows in general, all green colour, has too weak an effect in proportion to the other coloured rays, to give clear drawings; on the other hand all well-illuminated buildings, rock formations etc., give an excellent image.'

In 1851 (the year of Daguerre's death), Frederick Scott Archer introduced a new process which effectively replaced both the collotype and the Daguerreotype. It was known as the 'wet collodion process,' and was faster and far more reliable. The procedure was as follows. A piece of glass was first thoroughly cleaned and polished. It was then given a coating of the sticky solution of collodion (a solution of gun cotton in ether), followed by an even layer of iodide. Working in the darkroom with the aid of an orange safelight, the photographer immersed the plate in a bath of silver nitrate, while the previous coating was still moist. When the plate had turned a pale buff colour it was ready for use, and was placed (still wet) into a light-proof plate holder. The exposure time in the camera was roughly six seconds and development of the plate was again carried out in the darkroom. The latent image was 'brought out' with a solution of pyrogallic acid, and then fixed in 'hypo' or potassium cyanide. Finally, the plate was washed and dried, and given a protective coating of varnish.

Scott Archer was a portrait sculptor by trade, and had intended using photography merely as a source of reference to save the expense of long

sittings by a model. In his initial experiments, he had tried to use a solution of collodion on paper. It was only when he found that the substance would not adhere to the paper that the idea occurred to him of using a glass support. Although the procedure for preparing plates was cumbersome, the collodion process provided him with excellent results. Fox Talbot tried to claim that the collodion process came within the auspices of the processes he had patented, and he went as far as to warn photographers that they could not use the collodion process without first being granted a licence. As for Scott Archer, he died prematurely at the age of 44, without having received any rewards for the considerable amount of research he had done.

The wet collodion process was widely acclaimed by photographers in the USA and in Europe, but it

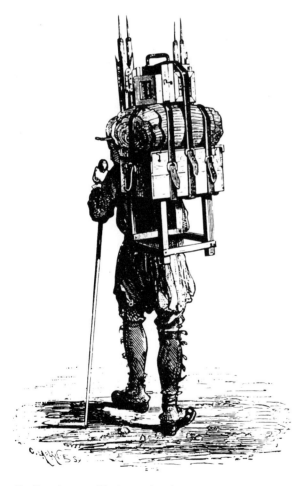

5 'Landscape Photographer.'

had its problems. Apart from spare clothing and camping gear, the equipment necessary for photographic work using the wet collodion process was an additional burden – cameras and plate-holders, a portable dark-tent which had to be erected on location for the preparation of plates, chemicals and dishes, the list seemed endless. Landscape photographers took on the appearance of explorers kitted out for long and arduous expeditions. Manufacturers and suppliers of photographic equipment and sundries invented all kinds of ingenious devices for making the equipment lighter and more portable. The fact that plates had to be prepared on location and used immediately led to considerable frustration – especially when, after having travelled perhaps hundreds of miles to photograph a particular view, the process failed due to a fault in any one stage in the process of sensitizing the plate. There was clearly a demand for a 'dry' plate which could be pre-sensitized, and could be stored for long periods, and used as required.

In 1871 an English doctor, Richard Maddox, published the results of his experiments on gelatine silver bromide emulsion, which replaced the use of collodion. The process was at first much slower than the wet collodion process, but was improved by an enterprising photographer, John Burgess, who advertised gelatine emulsion for sale in the *British Journal of Photography*. It was now possible to prepare dry plates by pouring the prepared solution onto a glass plate and allowing it to dry. The only disadvantage of the dry plate process was that the sensitized coating on the plate had a tendency to dissolve in a hot climate. However, the dry plates were further improved by Richard Kennett and Charles Bennett, and plates were eventually manufactured for sale by the Liverpool Dry Plate Company. These plates could be stored for reasonably long periods and used without further preparation. The exposure time was eventually reduced to a fraction of a second.

INTRODUCTION OF FILM

The main disadvantage of using glass plates was of course the high breakage factor – even the slightest crack in the glass would show on the final print as a dense black line which could ruin the photograph. The first film-based negatives were supported by a paper base. The film was stripped off the paper backing prior to being placed in the printing frame, where it was supported by glass. In 1861 Alexander Parkes invented the celluloid film as a

base for light-sensitive emulsion, but celluloid film was first marketed by an American firm at the suggestion of John Carbutt, an English photographer who had emigrated to America. Carbutt persuaded the firm to produce celluloid film in fine thin sheets which he then coated with a gelatine emulsion. Shortly afterwards, the Eastman Company produced a thin nitro-cellulose roll film, which was used by most photographers around the world for almost thirty years, until it was replaced by a non-inflamable acetate with an improved emulsion.

IMPROVED CAMERAS AND EQUIPMENT

The improvement in the chemical processes of photography was paralleled by the development of more sophisticated cameras with better lenses and shutters. Great demands were made on the ingenuity of manufacturers to produce mechanisms which kept pace with the progression from wet to dry plate photography. There were basically four main types of camera specifically designed for the use of dry plate and roll-film cameras, with many variations on each model by different manufacturers around the world.

Change-Box Cameras

These cameras incorporated in the design a separate chamber containing glass plates or sheet film, in batches of ten to 12. Attached to the chamber was a kind of light-proof sleeve which enabled the photographer to insert the sensitized plate or film into the slide-holder, without having to go into the darkroom.

Magazine Cameras

The magazine of these cameras could contain as many as 40 plates, which were housed inside the camera itself. There were variations on the design of the mechanism employed for changing each plate after exposure – the most common device allowed the plate to be dropped into a compartment at the bottom of the camera after being exposed, while the next plate was moved into position by a simple spring.

Roll-Film Cameras

The first mass-produced roll-film camera was introduced in the USA by George Eastman and W.H. Walker in 1885. The Kodak camera specially designed for use with roll films came on to the market three years later. The roller slide contained sufficient pre-sensitized film to make 24

6 Advertisement for cameras from a magazine, 1907.

exposures, and, with the introduction later of nitro-cellulose film, this was increased to 48 exposures. The first Kodak camera was extremely simple in design and construction, with a fixed-focus lens, one shutter speed, and a fixed stop – the age of the push-button snapshot had arrived, and the name Kodak became synonymous with the new concept of instant photography. The Kodak system had an immediate world-wide appeal; especially for the amateur, since all the processing and printing was done by agents of the Eastman Kodak Company.

Reflex Cameras

The principle of the single or twin-lens reflex camera is based on the method of inserting a mirror inside the camera at an angle of $45°$ to the lens. The mirror reflects the image onto a ground-glass screen built into the top of the camera, thus

permitting the image to be seen without the need of a black cloth.

EARLY LANDSCAPE PHOTOGRAPHY

While the Salon photographers were busy attempting to elevate photography to the status of 'high Art,' the landscape photographers adopted a more pragmatic approach to their work. All early landscape photography was essentially documentary – there was a need to retrace the footsteps of the great topographic painters, and to rediscover the world in terms of photography.

Travelling on foot, or perhaps in a specially converted vehicle, the landscape photographer became a somewhat conspicuous character, arousing curiosity, and sometimes hostility from country people. The dark-tent had to be erected near to the point where the photograph was to be taken, and, bearing in mind the amount of preparation necessary for each exposure, the photographer was fortunate indeed if he managed to make more than half a dozen photographs in one day.

One of the greatest landscape photographers of the early collodion era was an Englishman, Francis Frith (1822–98). He was also the largest publisher of scenic views, which were taken in Europe and Asia. Travelling through Egypt, he made large-format photographs of the temples of antiquity at Thebes, Karnak, Luxor and Abu Simbel. The collodion process was difficult to manipulate in the intense heat of the desert – he had to work quickly to make sure that the sensitizing solution remained moist on the plate right up until the point of exposure in the camera. Dust was another source of irritation, especially in a sandstorm when it got

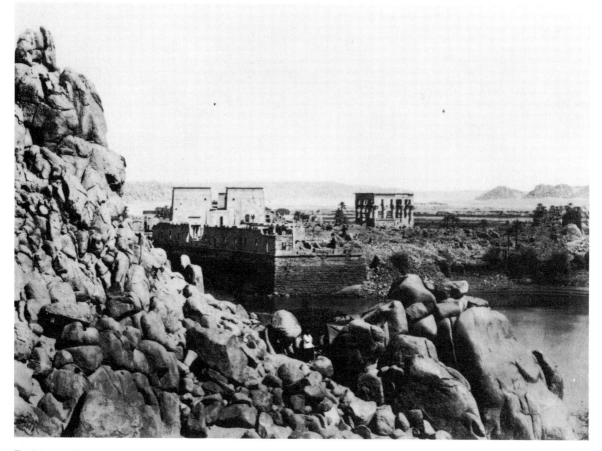

7 'Upper Egypt,' by Francis Frith (1863?). A well-composed photograph with an interesting foreground/background relationship.

into every crevice of the camera and plate holders. His darkroom was fitted into his wagon and covered with sailcloth as an extra precaution to keep out the penetrating rays of the sun. Frith graphically records in his journal the way that local tribesmen reacted to his strange apparatus; it seemed they thought that his wagon was some kind of travelling Harem containing many wives and moon-faced beauties!

The photographs which he eventually brought back to London aroused a great deal of interest. *The Times* newspaper, though unable to reproduce the photographs (photo-mechanical methods of reproduction had not yet been introduced), stated that they 'carry us far beyond anything that is in the power of the most accomplished artist to transfer to his canvas.' The London firm of Negretti & Zambra, who normally published fine engravings, commissioned Frith to produce a photographic survey of the Holy Land, so in 1857 he set out once more with all his photographic gear, and sailed for Cairo, and from there on to Palestine, Jerusalem, Bethlehem and Damascus.

He spent a year working with a large-format camera taking 8 × 10inch negatives. On his return to England he published large editions of selected photographs which were printed at the Frith studios in Reigate, Surrey, and published by James Virtue. There was a tremendous demand for the scenes of the Holy Land, due mainly to the fact that for the first time people who had not actually visited the Holy Land could see for themselves what it was really like. Up until that time their knowledge of the birthplace of Christendom was filtered through the highly coloured and somewhat over-romanticized illustrations produced by nineteenth-century reproductive engravers.

In 1859 Frith went back to Egypt. This time he travelled well over a thousand miles by boat up the Nile, and then by camel to the ancient remains of antiquity in the south. He was accompanied by a local guide, a cook, and a young assistant who helped prepare plates and who looked after the equipment generally. He eventually took his camera all over Europe and to the Fast East. The demand for his work became so great, however, that many of his photographs were taken without the care he had previously exercised for composition and light values. He was well aware of his shortcomings, as can be seen by the following extract from his journal: 'very rarely indeed does a landscape arrange itself upon [the photographer's]

focussing glass as well, as effectively, as he would arrange it if he could.' He also made reference to the way in which Turner was able in his paintings to convey atmosphere and to arrange elements of his composition according to his own judgement – something that he thought to be beyond the skill of the photographer.

It is perhaps sad that today the name of Frith is usually associated with postcard views of English provincial towns and seaside resorts – much of his pioneering work in the field of landscape documentary photography has been largely forgotton.

SAMUEL BOURNE

The intrepid explorer–photographer Samuel Bourne spent his childhood on his father's farm in Staffordshire. It was there that he acquired his love of nature which sometimes found expression in the beautifully written verse he wrote as a youth. His talent for verbal description proved useful in later years as an accompaniment to the landscape photographs he took on his expeditions to the Himalayas. He published at least three vividly written accounts of his travels, and extracts from his journals appeared in the *British Journal of Photography*. In writing about photography, Bourne was ever mindful of the limitations of the medium; he was also aware of the way in which photography can heighten our powers of perception – 'For my own part, I may say that before I commenced photography I did not see half the beauties in nature that I do now, and the glory and power of a precious landscape has often passed before me and left but a feeble impression on my untutored mind; but it will never be so again. . . .'

In all, Bourne made three photographic expeditions to the Himalayas; he was in fact the first European to record photographically the untrammelled vegetation of the foothills. He worked mainly with a large-format view camera, either 12 × 10inch or 8 × 4½inch. The quality of his work is superb and will stand comparison with some of the best landscape photography of the day. He derided the smaller photographs produced by the new 'pocket' cameras as mere 'scraps,' and he went on to say that 'one attached little importance to these diminutive transcripts of nature, which really convey no impression of the grandeur and effect of the scenes they represent.' He conceded however that if it were possible to make satisfactory enlargements, then the small-format camera might be of some use.

Each expedition demanded a great deal of

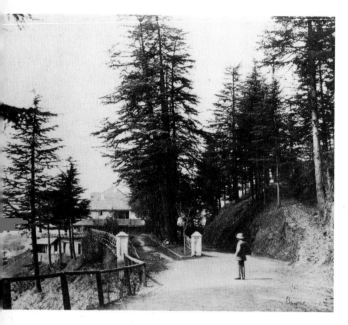

8 'View of Simla,' northern India, by Samuel Bourne. A rather uninspired composition – notice the slight movement of the figure in the foreground.

preparation, and on arrival, the support of thirty porters ('coolies') was necessary. The photographic equipment alone was cumbersome enough, with large portable dark-tents and the like, but Bourne also insisted on taking all his home comforts such as a supply of brandy and favourite chairs and tables. The first expedition lasted ten weeks, during which time he trekked a distance of 160 miles, often at high altitudes of difficult terrain near the Tibetan border where no white man had previously ventured, let alone take landscape photographs. There were immense difficulties in handling the large wooden camera and tripod; he would sometimes leave the main party to make a dangerous descent down a rock face in order to get a satisfactory composition. By the end of the first expedition he had produced 147 negatives and had reached an altitude of 15,282 feet in the region of the Taree Pass.

In 1864 Bourne headed another expedition to Kashmir with a team of thirty coolies to help carry equipment and provisions. Bourne expected the coolies to carry heavy loads to great heights, and on paths which would have been difficult to negotiate even for the climber unburdened with a pack. Consequently many of the coolies deserted him and there were numerous accidents. It was on this journey that he lost a case of glass negatives when the two coolies carrying the case slipped and were seriously injured on a mountain slope.

His last expedition to the Himalayas came four years later in 1868. He climbed the Manirung Pass to an altitude of 18,600 feet, leaving most of the terrified coolies behind at the base. He managed to expose only three negatives of the Pass before the view became obscured by cloud. By the time their journey was completed they were short of provisions and suffering from exhaustion.

Some of the scenery near the source of the Ganges was so spectacular that Bourne was made acutely aware of the limitations of the camera, as this entry from his journal reveals: 'It is of course totally impossible to give any notions of scenes and distances like these by the camera; the distances would run into each other and be lost in one indistinguishable hazy line, where the eye could trace that receding succession which conveys the idea of immense extent and distance. The photographer can only deal successfully with "bits" and comparatively short distances; but the artist, who has colour as well as outline to convey the idea of distance, might here find something worth coming for.'

The landscape photographer today of course has colour, wide-angle lenses, and can eliminate haze by the use of a filter. Nevertheless much of what Bourne said at that time still holds true today. He goes on to say: 'How often have I lamented that the camera was powerless to cope with these almost ideal scenes, and that with all its truthfulness it can give no true idea of the solemnity and grandeur which twilight in a vast mountainous region reveals partly to the sense and partly to the imagination.'

AUGUSTE BISSON

Another mountain photographer, less spectacular but no less courageous than Bourne, was Auguste Bisson. For him the challenge was the highest mountain peak in Europe – Mont Blanc. Even today, the experienced climber with the aid of modern climbing equipment would consider such a task to be a daunting prospect. But without special climbing gear, and with the burden of carrying photographic equipment, such a feat must have seemed near impossible. The first attempt, in fact, was a failure; but in 1861 Bisson, assisted by local guides and experienced climbers, made a successful ascent of the mountain. Their progress from stage to stage was slow and difficult; they climbed right through the night with lan-

terns. At times they were driven back by avalanches and snowstorms but eventually, in early morning, they reached the summit. In his small dark-tent pitched near the summit, Bisson had to perform the delicate operation of coating his plates. He made three exposures before descending the mountain back to Chamonix where a grand reception was held for him and the party of climbers.

9 View of the summit of Mont Blanc, by Auguste Bisson, 1861.

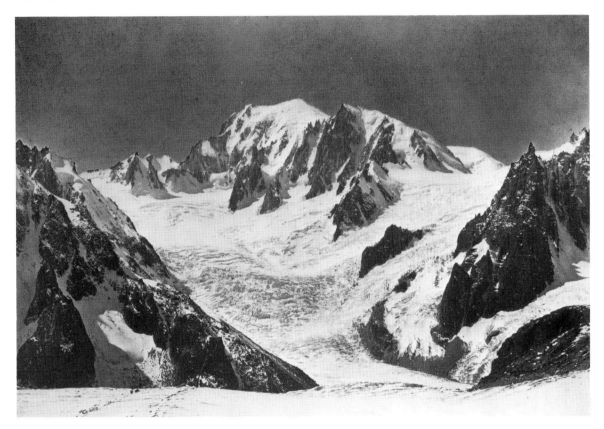

LANDSCAPE PHOTOGRAPHY AS ART

The belated acceptance today of photography as an art form owes much to the ideas formulated in the 1880s by the Englishman Peter Henry Emerson. Most of the Salon photographers of the period were busy concocting composite photographic images from facets of different negatives to make 'ideal' landscape views, and were trying to emulate the formal landscape compositions of the painting academies. Emerson called for a return to nature, saying that whenever the artist neglected nature and relied solely on his imagination the resulting images were bad. He was much taken with the ideas of the French Impressionist painters, who often worked directly from nature and revealed a particular feeling for the qualities of light in landscape. He openly scorned notable establishment photographers of the day such as Rejlander and H.P. Robinson, and he was merciless in his criticism of their work. Emerson believed that the artist's primary purpose was to register the effects of nature by making photographs from direct observation, rather than by making contrived images in the darkroom. He pointed to the example of landscape painters such as John Constable who worked continuously outside, drawing from direct observation. He went as far as to say that photography was superior to the graphic arts

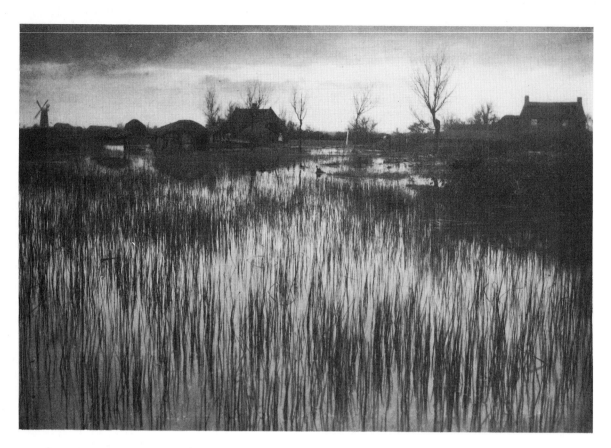

10 'A Rushy Shore,' the Norfolk Broads, by Peter Henry Emerson, 1886. This is a platinotype print which demonstrates Emerson's technique of soft focus to heighten atmospheric qualities in landscape.

such as etching and engraving, and that only the constraints of monochrome (colour-photography had not been successfully developed at that time) made it second to painting.

Emerson demonstrated his ideas by producing a folio of superb landscape photographs of river scenes in the region of the Norfolk Broads. In the text which accompanied this series, he offered some useful advice to landscape photographers, which is equally valid today – 'nature is full of pictures, and they are to be found in what appears to the uninitiated the most unlikely places. Let the honest student then choose some district with which he is in sympathy, and let him go there quietly and spend a few months, or even weeks if he cannot spare months, and let him day and night study the effects of nature, and try to produce *one*

picture of his own, which shall show an honest attempt to probe the mysteries of nature and art, one picture which shall show the author has something to say and knows how to say it, as perhaps no other living person could say it; that is something to have accomplished. Remember that your photograph is a rough index of your mind; it is a sort of rough confession on paper.'

Of all the photographers working at that time, Emerson was the most perceptive. He was deeply aware of the subtle nuances of light and atmosphere in landscape; his journal is full of delightful description of the kind which can only follow intense observation. '. . . The landscape seemed asleep, save where the smoke from the burning lime-kiln floated lazily through the air, shadowing an angler trudging home in the yellow splendour of the sinking sun.

'Then pillars of mist began to rise from the river, and we sailed solemnly through an ever-thickening expanse of sea-like fog gathering on marsh and river burying the herds and flocks.' And he continues, 'The moon arose silently growing like a flower in the night, a silver grey ball slowly

flushing to a golden tinge. Higher and higher rose the grey sea, so that only the vane of a passing wherry was visible as we glided past each other on the hidden river.'

For his own work Emerson used a large-format plate camera – making prints by direct contact with the negative, rather than by enlarging from a smaller negative. He believed that plates should be developed and prints made as soon as possible after the initial exposure, while the impression of the place was still freshly imprinted in the mind. He was adamantly against the notion of retouching either negatives or prints, a practice which he said likened the photograph to a 'botched-up' drawing. He always insisted that if his photographs were to be reproduced it should be done by the photo-mechanical process of photo-gravure, which was (and still is) the best method of reproducing all the subtle half-tones which are sometimes lost in other methods of reproduction.

Like many landscape painters, he observed that nothing in nature can be sharply defined; that the vibrancy of landscape forms demanded softer focus to render more sympathetically the atmospheric qualities of the Norfolk marshes. 'In this mingled decision and indecision, this lost and found, lies all the charm and mystery of nature.' The concept of soft focus was to some extent misinterpreted by his followers who produced a rash of fuzzy landscape photographs. Although the soft focussing technique was characteristic of his landscape work, he was nevertheless concerned to maintain an underlying sense of structure in his composition.

The photographic press at that time was full of correspondence related to Emerson's ideas about landscape photography; his notions about soft focus were derided by establishment photographers such as Robinson, who said that healthy human eyes never saw any part of a scene out of focus.

In 1890 Emerson dramatically retracted all of his earlier pronouncements about landscape photography and published an 'Epitaph in Memory of Naturalistic Photography.' He felt that things had got out of hand, and was deeply offended by criticisms made of him in the press. With the same fervour as he had expounded his earlier ideas about photography, he now openly denounced it as the 'lowest of all arts.' His retractions were warmly received by his former critics and rivals; he was made a member of the Photographic Society, and was duly rewarded with a medal for his services to the art of photography! He gradually withdrew from his work as a practising photographer, and more and more took on the role of a country gentleman, engaging in horticulture and other country pursuits.

The ideas expounded by Emerson and his circle of followers in London filtered through to photographic groups working elsewhere. In London a group known as The Linked Ring was formed by Horsley Hinton and George Davison. Hinton was also editor of *The Amateur Photographer*, and through the columns of that magazine he was able to make known the aims and aspirations of the group. They sought to emancipate photography from the constraints of pure technique; to probe beyond the boundaries of science. They believed that photography could progress only if it were recognized as an independent art form. Their annual exhibition in London was called The Photographic Salon, and was notable for the great care and restraint that went into the selection and hanging of the photographs. They were displayed in one continuous line at eye level, rather than filling all the available wall space, as was the case in previous exhibitions. The relative success of the group proved to be a great stimulus to the establishment of associate groups in other countries, notably in Paris, Brussels and New York.

The American group was by far the most significant – a number of highly talented photographers accepted the leadership of Alfred Stieglitz, including Eduard Steichen, Frank Eugene, Alvin Langdon Coburn, and Clarence H. White.

Stieglitz had originally intended to take up a career in mechanical engineering, and went to Germany with this express intention. While he was there, however, he became distracted by the work being done by H.W. Vogel, an expert in photographic chemistry. He eventually worked as an assistant to Vogel, and had to relinquish all thoughts of a career in engineering. On his return to New York he joined the Society of Amateur Photographers, and like Horsley Hinton in London, he was appointed editor of the main journal published for amateur photographers.

Stieglitz became one of the most influential photographers in the first decade of the twentieth century – he employed the new techniques of dry-plate photography, and used hand-held cameras. He liked to work directly on location and is known to have waited for hours on end in a blinding snowstorm on Fifth Avenue, just to photograph a horse-drawn tram. He acquired a reputation for

his reportage photography and for his superb portraiture. He also made a great number of cloud studies on 5 × 4inch plates. He called these prints 'Equivalents' because he felt that the abstract nature of these fragments of cloud were in some way parallel to his own preoccupation with thoughts about the meaning and purpose of life. 'I wanted to photograph clouds to find out what I had learned in forty years about photography. Through clouds to put down my philosophy of life.' Seen out of context in relation to a land mass, the cloud studies were viewed by the public as purely abstract forms, which they found difficult to come to terms with. Although painters such as Constable and Turner often made cloud studies, they were rarely exhibited and were usually made as reference sketches for larger paintings. People at that time, however, were not conditioned to seeing fragments of a landscape in isolation.

Perhaps the most important quality that Stieglitz brought to photography was a feeling of spontaneity, and of technique used in the service of an idea rather than as an end in itself. He gave great encouragement to a number of younger photographers, among them Paul Strand. Strand began his photographic career by making close-up photographs of machine parts and of objects found on the seashore in Maine. From these modest beginnings he went on to become one of the most prolific landscape photographers of the modern school. He has travelled widely throughout the world, producing landscape photographs which demonstrate a unique sympathy and understanding for each place; he is especially concerned with the relationship between the land and the people who work the land.

In 1920 a Californian photographer, Edward Weston, gave up trying to emulate the soft-focus techniques pioneered by Emerson and other European photographers. Instead, he concentrated on still-life photography and on abstract studies of the human form. He pushed the technique to its limits, producing prints with fine definition and subtle gradations of tone. His approach became purist – he made contact prints directly from 10 × 8inch negatives. He contended that the photographer should be able to envisage the finished print before actually taking the photograph. His own photographs were carefully composed, and precision in technique became almost an obsession. In all his work there is an over-all clarity of definition, and details in the foreground, middle-distance and far-distance are all in sharp focus. His pursuit of technical excellence, however, was a means to an end – his main concern was to register detail as precisely as was possible within the constraints of the medium; whether his subject was a model posing in the studio, or the vast sand dunes of Oceano, California.

His best known landscape photographs were produced at Point Lobos in California. It was a location he never tired of, with its abundance of plant life, variety of trees, and rock formations worn and weathered by the Pacific Ocean. He photographed the same places over and over again in different conditions of light, at different times of day, and in different seasons of the year. Today Point Lobos has become a Mecca for American landscape photographers, many of whom go there in the hope of capturing something of the same spirit which originally inspired Weston. The photographs that he produced, however, can only come about by a long association with a particular place, and as the result of an understanding and awareness of visual phenomena which may not be immediately recognizable to the casual observer.

Weston died in 1958, leaving a thousand of his best negatives, with special detailed instructions on the methods to be employed for reprinting, to his son. He also left his 'day books,' which are essential reading for all would-be landscape photographers.

In 1932 a group of young photographers, who were much impressed by Weston's work, banded together and called themselves Group f64. In addition to Weston, who was an honorary member, the group included Ansel Adams, Imogen Cunningham, Henry Swift and Sonia Noskowiak. Their association was largely informal, though their collective ideal was to produce landscape photographs which went beyond the boundaries of the conventional values of pictorial composition.

Ansel Adams became the main protagonist of what came to be known as 'straight photography.' His many books on the technique of photography have since become standard manuals of instruction. Adams has a great feeling for landscape; not only as a photographer, but as a naturalist and as an ardent conservationist. The beautiful luminosity of his landscape prints are the result of skilful prejudgement of the relationship between the brightness of the subject, the exposure, and the

11 'Sand Dunes, Sunrise, Death Valley National Monument, California,' by Ansel Adams, 1948.

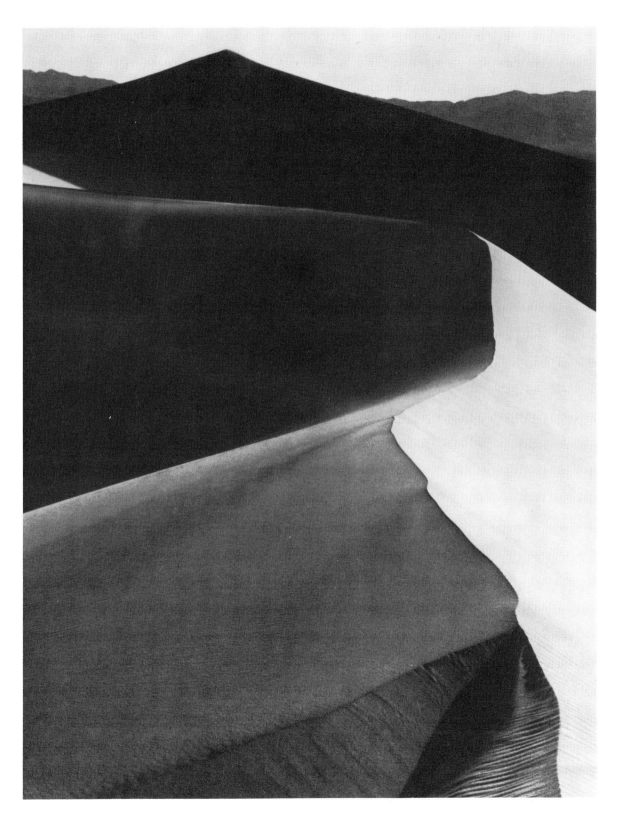

subsequent development of the film. His technical command of the medium enables him to produce prints which contain a wide range of tone. With the aid of a photo-electric exposure meter, he is able to determine the light values in different parts of the scene which he is about to photograph. The various light readings are then balanced in relation to the exposure, and in consideration of his methods of development and printing. So, more than most photographers, he has a good idea of the kind of image that the camera will yield, prior to development and printing.

Although many photographers in the thirties concentrated on straight landscape photography, there were others who produced some very fine landscape photographs as a consequence of pursuing other ends. In 1935 the US Government decided to recruit a team of photographers to make a visual record of the drought-stricken and over-worked farmlands of the southern states.

Each photographer was given an allowance for living expenses, and for equipment and photographic materials. The administration, with special responsibility for the resettlement of agricultural workers, was known as the Farm Security Administration. It employed some good photographers for the scheme, notably Walker Evans and Dorothea Lange, the latter having been a member of the Group f64. Evans travelled to the south to photograph the share-croppers, whilst Dorothea Lange recorded the barren wastes of the desolate farmlands in Texas. She also produced some moving portraits of the groups of migratory workers tramping from camp to camp. This kind of documentation presented photographers with a new kind of challenge. They were carefully briefed as to the specific requirements of the administration and there was little opportunity for self-indulgence. Every photograph had to make a specific comment about the plight of the people, the animal life, and the barrenness of the land. Margaret Bourke White was one of the few photographers to make use of aerial photography, producing some memorable photographs of the patterns made by the ploughshares in the fine exhausted soil.

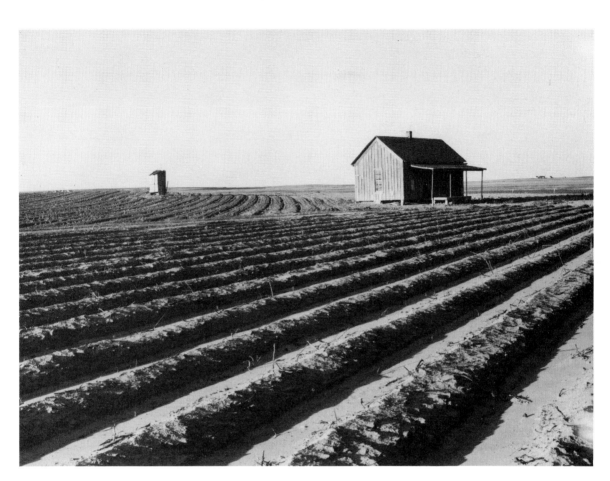

12 *Left:* Scene near El Paso, Texas, by Dorothea Lange, 1938. A superbly composed photograph which clearly anticipates the modern movement in landscape photography.

13 Farm abandoned after the soil had become exhausted by mechanized farming, by Dorothea Lange, 1938.

All of these documentary photographs were of course meant to be supportive to the text written for various journals and newspapers, and syndicated throughout the world. They were not intended as 'art' photographs, though in the course of time they have come to be recognized as works which have had a seminal influence in the development of contemporary photography. During the period 1935–43, nearly a quarter of a million photographs were taken, most of which are now held in the Library of Congress.

ENGLISH TOPOGRAPHIC PHOTOGRAPHY
The English tradition in pictorial photography pioneered by Emerson was carried on to some extent by his follower, George Davison, and by Frederick H. Evans. The latter was primarily concerned with architectural photography, but he also produced some fine examples of landscape photography.

The influence of the painter Paul Nash on the development of English photography has yet to be fully realized. Initially Nash used photography as a source of reference for his landscape paintings. Later on, however, he used the medium as a way of discovering forms and structures which had previously gone without recognition. Reviewing a book about Professor Karl Brossfeldt's photographs of plant life and growth, Nash referred to the 'peculiar power of the camera to discover formal beauty which ordinarily is hidden from the human eye.'

Unlike Weston and other American photographers, Nash was not overtly concerned with the refinements of photographic technique; the only camera he owned was an inexpensive pocket camera, a Kodak No. 1A given to him by his wife. Within the limits of the simple mechanism of this camera, he nevertheless produced some remarkable landscape photographs. Throughout his life he was troubled by severe attacks of asthma, and as the condition got worse he began more and more to rely on the camera as a means of self-expression. The discovery of a new 'place' was usually the starting point for his work – 'There are places, just as there are people and objects and works of art, whose relationship of parts creates a mystery, an enchantment, which cannot be analysed.'

Whereas Weston found his inspiration at Point Lobos on the West Coast of America, Nash was fascinated by the flat marshland of Romney Marsh in Kent, and later, by the soft undulating chalkland landscapes of Wiltshire and Dorset. He also found a means of presenting analogies between natural forms and man-made artefacts. Seemingly inanimate objects such as a fallen tree he photographed and renamed 'Monster' or, 'Stalking Horse.' The trees seen in an uprooted horizontal position were, he believed, released from their previous life of being solidly implanted in the earth growing upwards. In their new life, the roots and branches take on the appearance of an imaginary monster – 'the now inanimate objects are alive in quite another world.'

Working as an official war artist attached to the RAF during World War Two, Nash discovered a more ominous landscape near Cowley in Oxfordshire. A large field had been requisitioned as a dump for the tortured remains of enemy aircraft which had either been shot down or had crashed. This scene presented a potent analogy between the normally tranquil English scene and the terrifying landscape of derelict war machines. From the photographs he took at Cowley he produced his most memorable painting, 'Totes Meer.'

Like Emerson, he wanted to heighten our awareness of aspects of landscape which we take for granted – he sometimes referred to his landscape photographs as 'unseen landscapes.' He said that 'the landscapes I have in mind belong to the world that lies visibly about us. They are unseen merely because they are not perceived.'

During the thirties, Bill Brandt produced a series of documentary photographs of the depressed regions of north-east England. Working on his own initiative, he produced a series of photographs which paralleled the work being done by Walker Evans and Dorothea Lange for the Farm Security Administration in the USA.

Brandt had worked with Man Ray in Paris, and from him had learnt the value of experiment and the way in which photography can be an ideal medium for the expression of surrealist ideas. His own technique developed by trial and error. The influence of the surrealist movement gives his work a particular presence. He is prepared to wait as long as is necessary to photograph a landscape in just the right conditions of light. During the blackouts of the war he was able to take a series of photographs of deserted London streets by moonlight.

He recalls that during the thirties there were essentially two trends emerging – the poetic school, of which Man Ray and Edward Weston were the main protagonists, and the documentary school. Brandt confesses to being influenced by both schools, though initially it was the documentary aspect of photography which interested him most. At that time the extreme social conditions in England contrasted sharply: in the north, coal miners were trying to feed their families on starvation wages, whilst in the more affluent south the wealthy indulged in various leisure pursuits. Brandt's photographs of that period are the best documentary evidence we have of the depression. It was not until after the war that he became interested in the unexplored potential of landscape.

His feeling for experiment, combined with a chance 'find' of an unusual camera in a second-hand store near Covent Garden, led him to produce his best known series of photographs, 'Perspective of Nudes.' The camera had a wide-angle lens, but no shutter, and the aperture was as small as a pinhole. He had to work 'blind', ranging the camera in the general direction of the subject, without knowing what kind of image the negative would yield until development. The resulting prints were truly remarkable; by purely photographic means, Brandt had produced incredible distortions of the model, which added a completely new dimension to the medium.

What most distinguishes Brandt's landscape photographs from those of other photographers is his poetic vision. He attempts the seemingly impossible task of going beyond the external appearance of things to hint at mysterious underlying values. By fusing together deep shadows and strongly contrasting tones during the printing-stage (he has been known to spend a day working on

a single print), he creates a sense of drama, a feeling for atmosphere, composed with a kind of monolithic simplicity.

The resurgence of interest in landscape photography today is due in part to the influence of Brandt, Weston, Adams and others. Amongst many younger photographers, however, there is a deeper concern for nature conservation, which underlies any interest in aesthetics. Above all, there is the human need to share one's direct experience of nature, and in this respect the medium of photography is eminently suitable.

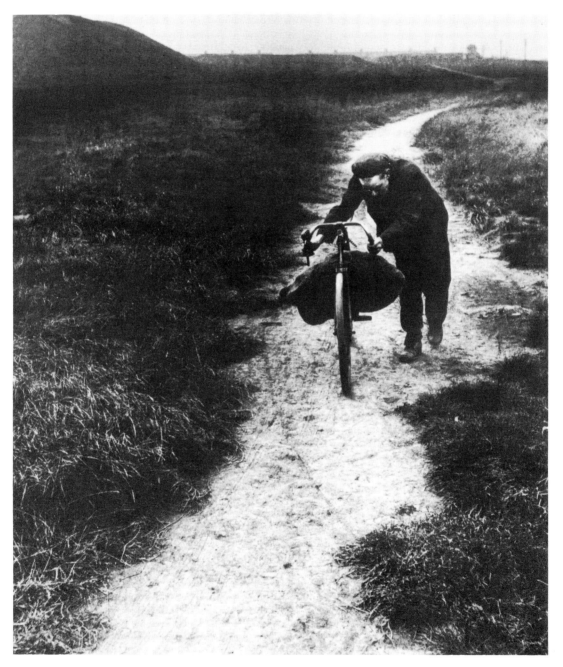

14 'Coal Searcher Returning Home,' Jarrow, by Bill Brandt.

2 Equipment

Ever since the days of the Victorian cameraman with his trappings of wood, brass and leather, our conception of photography has been distracted by all the shiny hardware. To some, the prospect of those incomprehensible dials, switches and numerals is quite alarming. Others, however, seem to develop an unwholesome interest in the technicalities for their own sake. They collect gadgetry, quote data, plot graphs, calculate for reciprocity failure and join earnest debates on abstruse matters of chemistry or the compounding of lenses.

Neither of these extreme attitudes is helpful. There is no need to be frightened: simple equipment can be useful, sophisticated equipment may be used in a simple way, and, best of all, automated cameras are available which will do all the work for you electronically.

On the other hand, the photographer whose attention is concentrated chiefly on the technical aspects of his work is in danger of missing the whole point. The essence of all serious photography is communication; if the picture does not communicate, it is useless, no matter how much technical virtuosity it demonstrates.

Equipment has just one purpose – to enable you to produce the sort of pictures you want. And if exactly the sort of picture you want can be produced by a pinhole camera, then you would be wasting your time and money in buying a Hasselblad. If, however, you wish, for example, to shoot in low levels of light and to produce large-scale prints with great resolution of detail, then you are certainly going to need a sophisticated camera with a high-quality lens.

There is no inherent virtue either in simplicity or in sophistication. It is certainly true that a good photographer can produce an exciting photograph with the most elementary equipment, and conversely that no amount of expensive, complicated paraphernalia will turn a novice into an expert. Nevertheless, the expert will not normally wish to cope with unnecessary constraints imposed by primitive equipment; he will prefer to have as much control over his medium as possible.

The choice of equipment then, depends primarily on what you wish to achieve. You should examine your motives. What are you taking the photograph for?

This does not merely mean: do you wish to give slide shows, or exhibit prints or illustrate books? It means also: what are you attempting to communicate in your work? Are you concerned with atmosphere, or details? Do you wish to invoke the history of the place, or its 'feel'? Are you interested in more purely visual phenomena, in the designs and patterns which can be found in landscape? Or, again, are you simply concerned with factual information about the land – possibly in connection with geology, natural history or geography?

It might be necessary to carry cumbersome, large-format cameras and ancilliary hardware over miles of difficult, mountainous country, if what you wish to communicate demands a high degree of technical quality. (The beautiful, evocative images of John Blakemore (see p. 146), for instance, are greatly enhanced by the subtlety of tone and the resolution of detail made possible by the large negatives produced by his old MPP.)

If, however, such quality is not absolutely of the essence, then a 35mm SLR system offers great advantages of portability and flexibility.

There are, of course, so many variables that it is not possible to give simple, straightforward, unequivocal advice. Instead, we have provided information on the main types of camera likely to be useful in landscape photography. We have given examples and we have listed the advantages and disadvantages of each type. Although we have described a large range of ancillary equipment, the really essential items are fairly few.

CAMERAS

The three most common negative sizes, 35mm, $2\frac{1}{4}$inch sq. and 5×4inch, provide a useful means of classifying cameras. Within each of these categories we have chosen the type or types of camera likely to be of most use for landscape photography.

We have not discussed individual models in detail, since technology advances so rapidly that changes in specification could render such information obsolete within a matter of months.

35mm

These are miniature cameras which use a roll of perforated film, producing a negative area of 36×24mm (approximately $1\frac{1}{2} \times 1$inch). The cost of material per negative is appreciably less than that of a larger format. The film is sold in a metal cassette, which is loaded directly into the camera. Standard lengths giving 36 or 20 exposures are available, but you can lower the cost of material even further by buying film in bulk and filling your own cassettes.

15 High-quality 35mm SLR cameras.

The most useful type of 35mm camera is the Single Lens Reflex (SLR). The advantage of this system is that the main taking lens of the camera is used to produce the image which appears in the viewfinder. A hinged mirror reflects the light from the lens onto a focussing screen. When the firing button is pressed the mirror swings out of the way, allowing the light to pass directly onto the film through a focal plane shutter. As soon as the shutter has finished its scan, the mirror returns to its former position. A pentaprism is used to correct lateral reversal, so that the image in the viewfinder appears the right way up and the right way round.

And since the distance between the lens and the focussing screen is precisely the same as that between the lens and the emulsion, the viewfinder will show exactly what will reach the film.

This means, of course, that it is very easy to check composition, focus and depth of field, and to see the effect of any particular lens or close-up accessory. To make focussing even easier, most cameras incorporate a Fresnel lens with a microprism centre under the ground glass screen. The Fresnel pattern of concentric rings provides a bright image all over the screen. The microprism spot, as its name suggests, contains many tiny prisms which are placed in such a way as to split the image into a series of small dots unless it is precisely in focus. Sometimes a split-image rangefinder is incorporated in the central spot. In this

system the image is split into two separate halves which fit together only when exact focus has been reached. Since a split-image range-finder is not very effective with certain landscape subjects such as sky, snow or grass, a microprism collar is often fitted around the central spot.

Whatever system is used, it is always possible to focus the subject on any part of the ground glass screen.

Some cameras and lenses are fitted with an automatic diaphragm which can be preset to a particular f. number. The diaphragm remains fully open at all times except for the brief moment of exposure, when it automatically stops down to the selected aperture. This enables focussing and composition to take place with the brightest possible image. A manual override is provided to allow a visual check to be made of the depth of field.

Most SLR cameras incorporate a through-the-lens (TTL) metering system. This measures the light which actually passes through the lens, and immediately gives a reading in the viewfinder. This reading is either in the form of a light-emitting diode (LED) display or of a needle which can be aligned with marks indicating the correct exposure. The system is coupled with the shutter speed control, so that adjustments to the speed and aperture can be made until the correct exposure is shown.

With cameras having an automatic diaphragm, there is a problem that a reading taken at full aperture would be of no use if the actual exposure is to be taken at a smaller aperture. This difficulty can be overcome by making the meter switch also stop down the diaphragm to the selected f. number, so that the system measures light which will actually reach the film.

Alternatively, the metering system can be linked to the aperture controls, so that, after measuring the light passing through the lens, it can give a reading which has been corrected for the f. number at which the exposure will be made. This is called 'open aperture' or 'full aperture' metering, and offers the advantage of presenting a bright image in the viewfinder while the controls are being set. Lenses and accessories, however, have to have compatible couplings for the meter, otherwise the system must be made to operate on closed aperture.

Even more automation is available with cameras which employ either shutter priority or aperture priority automatic metering. With an aperture priority system, an electronically controlled shutter will provide precisely the right exposure time for any chosen aperture. And, similarly, with a shutter priority system, a shutter speed can be selected and then by using an electronic device to control the diaphragm, minute adjustments can be made to give exactly the correct aperture. With these cameras all you have to do is to focus and press the shutter release button. As readings are taken continuously right up to the moment of exposure, great accuracy is assured, even in rapidly changing light conditions. With the more expensive cameras it is possible to override the electronic controls and to select speed and aperture manually; for example, if you wish purposely to over- or under-expose, or if you are faced with lighting conditions which might be too difficult for the automatic system.

TTL metering systems employ various methods of measuring light. The problem is that when the light has passed through the lens it forms an image containing both light and dark areas which may differ very considerably in their brightness. If, for example, a photocell in the metering system is so placed that it receives only the bright light from the sky in the background, it will probably give a reading which is quite wrong for the main part of the subject.

The three main methods of overcoming this difficulty are: over-all metering, centre weighting and spot metering. The over-all method uses light from the whole area of the image which is integrated to give an average reading. With the spot method, the meter reads a small central section of the screen, which must be pointed at appropriate parts of the subject before making an exposure. Centre weighting provides a sort of compromise, in that it reads the whole screen but is more sensitive to the central area.

The biggest advantage of TTL metering is that, since it measures the light which will actually fall on the emulsion, it automatically compensates for different lenses, for close-up devices, for filters or, indeed, for any accessories which alter the brightness of the light passing through the lens.

35mm SLR cameras use a focal plane shutter, consisting of two blinds made of cloth or metal, which is mounted immediately in front of the film. When the shutter release button is pressed, one of the blinds moves across the film, exposing it to the light; the other shutter then follows the first and covers up the film again. During longer exposures, the first blind will have uncovered the film com-

pletely before the second blind starts to move.

With short exposures, however, the second blind will be on its way before the first has reached the end of its travel, so the film is exposed through a narrow slot which scans across its surface. The blinds always move at the same speed, so the amount of exposure is determined by how soon the second blind follows the first.

Except when an exposure is being made, the blinds of a focal plane shutter completely cover the emulsion, so the lens may be removed without risk of stray light fogging any part of the film. This allows lenses to be changed quickly and easily at any time.

The best 35mm SLR cameras form part of a complete system, with a wide range of interchangeable lenses, viewfinders, extension tubes, motor drive units and other accessories. Apart from equipment supplied by the makers of the camera, lenses and accessories can be obtained from independent manufacturers.

All this can make a 35mm camera extremely flexible in use. It is perfectly easy, for instance, to carry a few rolls of film and a camera with a standard lens, a wide-angle lens and a telephoto lens. You could then have as great a range of optics as you would normally use with a large-format camera, and you would be free from the burden of all the extra gear. You would probably not even need a separate exposure meter or a tripod.

The main disadvantage of 35mm cameras is that they produce negatives or transparencies which require a greater degree of enlargement. This means that they must be extremely sharp in the first place; a better lens, therefore, is required to provide the same quality as would be obtained from a comparable 5×4inch negative or transparency. The degree of enlargement also makes it important that even greater care be taken to avoid such defects as scratches, dust or drying marks. Obviously the grain is more likely to be apparent, and if graininess is not desired, it must be reduced by employing a fine-grain developer and by using a slower film. Altogether more care, precision and skill are necessary when using these cameras if the technical quality of the work is to approach that of the larger formats. For the same reason, many printers dislike having to use 35mm transparencies.

Although the lightness and compactness of 35mm cameras tend to make all of them quicker to use than other types, handling characteristics vary considerably from model to model. The smallest do not necessarily handle the best; a certain amount of weight is useful to damp vibration when making an exposure, and indeed, you might find that your hands are too large to distinguish the controls easily. It is important to try out several different models before making a purchase.

Among 35mm SLR cameras of extremely high quality are those made by Nikon, Olympus, Contax, Topcon, Pentax, Canon, Minolta and Leica. All of these have an extensive range of lenses and other accessories. Somewhat less expensive, but still perfectly adequate are cameras made by Praktica and Zenith.

2¼inch sq.(6 × 6cm)

Cameras producing negatives or transparencies of this size generally use 120 roll film, giving 12 exposures per roll. There are two main types: twin lens reflex (TLR) and single lens reflex (SLR).

The twin lens reflex camera, as its name suggests, uses two separate lenses mounted one above the other. The lower lens projects its image directly onto the film, while the image from the upper lens is reflected by a fixed mirror onto a horizontal focussing screen. Both lenses are of identical focal length and are mounted on a panel which is moved in and out by the focussing knob. When the image on the screen is in sharp focus, so will be the image on the film. Most screens are provided with a light-shield and a retractable magnifier to facilitate really accurate focussing.

The taking lens is equipped with a diaphragm, but the lens for the viewfinder remains permanently at full aperture. Focussing and composing, therefore, are always performed with the brightest possible image, even when the taking lens is stopped down. The disadvantage of this is that it is not possible to make a visual check of the depth of field.

The image on the focussing screen is transposed from left to right, but for landscape photography this lateral reversal is not really significant. Another minor drawback is parallax discrepancy. Since the two lenses are mounted slightly apart, they reflect very slightly different images. The parallax effect increases the nearer the subject is to the camera, and with close-up work, allowance must be made for the fact that the image in the viewfinder will not correspond exactly with that projected onto the emulsion.

An advantage of the TLR system is that the image on the focussing screen remains in view, even during the time of the exposure. The camera

is also mechanically simpler than SLR types. Since the reflex mirror is fixed, there is less noise and vibration when the shutter is released.

Although the square format can sometimes be restricting if cropping of the image is not practicable, it does allow the camera to be held upright, whatever the shape of the subject.

TLR cameras do not have a very extensive range of accessories. Indeed, only the Mamiyaflex at present offers the facility of interchangeable lenses, and even in this case the cost is increased because it is necessary to change both upper and lower lenses complete with the shutter mechanism.

Nevertheless, TLR cameras can be relatively inexpensive and can produce very high quality results. Good examples are manufactured by Yashica, Mamiya and Rollei.

16 2¼inch square cameras. (a) Yashica. (b) Hasselblad.

SLR cameras which use 120 film usually produce a negative of 6 × 6cm like that of the TLR cameras. There are, however, a few models which produce negatives of 6 × 4.5cm or of 6 × 7cm (ideal format).

The larger SLRs possess many of the advantages of 35mm SLR cameras. What is seen in the viewfinder is exactly what appears on the film, a visual check may be made of the depth of field, TTL metering may be fitted, and a wide range of accessories is often available.

There are two types, those with eye-level viewfinders and those with waist-level viewing screens of the same size as the negative. The first type is essentially an enlarged version of the conventional 35mm SLR, complete with pentaprism and focal plane shutter. The second type uses a box-like body with interchangeable lenses at one end and interchangeable magazines at the other.

This second type offers the greatest possible flexibility. Some camera systems of this type carry a huge range of accessories, lenses and alternative equipment, including optional eye-level pentaprism viewing. They provide all the items to be found in the best 35mm systems, plus the advantage of having the film loaded into a separate container which attaches to the back of the camera. Several of these magazines can be loaded in preparation for a field trip, so that a great deal of time can be saved in changing films on location. Another great advantage is that a magazine can be removed after any number of exposures and then returned to the camera at a later stage to continue from the same point. So, by loading different films into various magazines, it is possible to shoot individual frames on whatever material one chooses. In some systems, magazines are available to provide negatives in several different formats, or to take instant picture material.

When the magazine or the lens is changed, the film is protected from the light by a metal slide which fits into a slot across the mouth of the magazine. As a safeguard, a catch is fitted so that the magazine cannot be removed until the slide is in place.

Since the emulsion is protected by the slide rather than by the shutter, it is not necessary to use a focal plane shutter in order to have interchangeable lenses. And although some models do offer a focal plane shutter, others use a leaf-type shutter. A leaf shutter is made up of several thin, overlapping blades which open and close to allow the light to pass for the moment of exposure. The time of the faster exposures is controlled by the tension of a spring which is released by the firing button. Longer exposures are timed by an escapement, and there is also a B setting which keeps the shutter leaves open as long as the release button is depressed.

This type of shutter may be placed between two of the lens elements inside the lens itself (an interlens shutter). The disadvantage of this is that each lens must have its own built-in shutter, which adds to its cost considerably. Alternatively, a 'behind the lens' shutter may be placed just inside the camera body.

SLR cameras using 120 roll film include: Pentax, Hasselblad, Bronica and Rolleiflex, all of which are of extremely high quality.

Cameras of this size combine some of the merits of both miniature and large-format cameras. Although heavier and bulkier than 35mm cameras, they are still fairly portable and quick to handle, and frames can be shot in quick succession. The size of the negative helps to ensure results of good technical quality. On the other hand, both the cameras, and, when available, all the other components of the system, are more expensive than 35mm equipment of comparable quality. Film costs too are obviously higher per shot.

5 × 4inch

Cameras using sheet film of this size are large, heavy instruments which are designed to be used on a tripod. Optically the system is extremely flexible, but it is very slow to use and requires a good deal of ancillary equipment.

The lens is mounted on a panel at the front of the camera and the ground glass viewing screen on a panel at the rear. The two panels are connected by bellows, and focussing is accomplished by moving them closer together or further apart.

On a monorail camera the panels can be slid quickly along the rail until a coarse focus is achieved, then locked before fine focussing is carried out by turning a knob. A considerable extension of the bellows is possible, so that the camera may be brought very close to the subject.

Lenses are interchangeable and a wide variety of focal lengths is available. Each lens is mounted on its own panel and carries its own diaphragm and inter-lens leaf shutter.

The film is carried in a darkslide which fits into the rear panel. Each shot is taken on an individual piece of film which must be loaded into the slide in darkness. A thin sheet of plastic slides over the film to protect it until it is inside the camera. Since each darkslide can hold only two pieces of film, one on each side, a considerable number may be needed on a field trip.

To make an exposure, the lens is opened to its widest aperture and the image is framed and focussed on the ground glass screen. Since mirrors and prisms are not normally used, the image will appear upside-down and laterally reversed. A grid of fine horizontal and vertical lines may be etched into the screen to facilitate accurate positioning of the subject, and a magnifier is often used to obtain precise focus. The image is much more easily seen if the screen is shaded, and the traditional black cloth over the photographer's head is often used for this purpose.

A particular feature of this type of camera is that the position of the lens panel and that of the rear panel carrying the film may be altered in relation to each other, in order to manipulate the image. Either panel may be moved up and down, or from side to side, or be tilted backwards and forwards, or swung to the left and to the right. These are called camera movements, and are used to control the depth of field, to adjust the shape of the image, and to include or exclude parts of the image without altering the main viewpoint.

Both panels are usually equipped with spirit levels, and calibrated scales are fitted so that all movements can be precisely controlled and readily zeroed. Locking devices are fitted so that the controls can be held rigidly in position once the delicate adjustments have been made.

When a satisfactory composition has been achieved, the panels are locked in position and the exposure is calculated. Although most photographers use a separate exposure meter, extremely accurate spot meters are available which slip into place next to the ground glass screen, and can be

used to take readings from any part of the actual image.

The exposure having been determined, the diaphragm is stopped down to the required f. number, and the shutter is closed and set to the appropriate speed. The darkslide is then pushed into place in front of the viewing screen, which moves back on springs so that emulsion of the film is now in precisely the same plane as that previously occupied by the surface of the ground glass. As the film is now safely inside the camera, the protective sheath is removed from the darkslide, and the exposure is made by firing the shutter, usually with a cable release. The sheath is then replaced, and the slide removed from the camera.

The large negatives produced by these cameras are easy to retouch, and they provide prints of extremely high quality. A very wide range of film types is available, and, if desired, each individual shot can be taken on a different emulsion. A polaroid back is usually available so that instant pictures can be obtained, either as pilot shots or as an end in themselves.

17 Sinar monorail camera. A great deal of control over the image is provided by the many adjustments which are possible with these cameras.

Since the films can be processed individually, it is possible to vary the development for each picture. On the other hand, the cost of material per shot is considerably higher than that of roll or 35mm film. The camera itself is also expensive and it requires a good deal of extra equipment.

For the landscape photographer the size and weight of all the gear is a distinct disadvantage. It is a considerable undertaking to carry the camera, spare lens panels, tripod, exposure meter, film, dark cloth and all the other little bits and pieces to anywhere but the most accessible of locations. The fact that eighteen bulky metal darkslides are necessary to provide the same number of shots as can be obtained from one tiny roll of 35mm film will give some idea of the difficulties.

Nevertheless, some photographers are prepared to face all the problems of transportation in order to enjoy the superb technical quality and the great control over the image which these cameras offer.

Sinar, Arca Swiss and Linhof are good examples of 5 × 4inch cameras.

OTHER TYPES OF CAMERAS

We have described the types of camera most likely to be useful to the serious landscape photographer – those which provide him with good quality images and control over his medium, and which enjoy the benefits of standardized components and access to a wide range of readily available, easily processed material. However, virtually *any* camera can be used to photograph landscape and, occasionally, photographers have used unlikely equipment to produce the results they seek. Sometimes the very inadequacy of the optical system has been exploited by using distortion or chromatic aberration to achieve a particular effect. The important point to remember is that the effect must contribute to the communication; it must help the photographer to say what he wants to say. If it is merely an effect for its own sake, inevitably it will look like a commonplace trick, or worse, like simple incompetence.

Among the sorts of camera which have a limited application to landscape photography are instant, pinhole, panorama and stereo.

Instant Cameras

Instant picture cameras enable you to see the results of a shot within a matter of seconds. The peel-apart type of material is pulled from the camera after the exposure has been made. As it is pulled out, it passes between two rollers which burst a thin pod of jelly-like chemicals, spreading them between the negative and positive sheets to form a sort of sandwich. The processing has now started and is timed by the photographer. The time varies with the type of emulsion used, the

average being about 30 seconds.

During processing, the silver salts which have not been used to make the negative image move into the positive material to form the positive image. When the 30 seconds, or whatever, are up the negative and positive are simply peeled apart and you have your finished photograph. Some material of this type produces negatives which can be cleared in a special solution and then used as conventional negatives in the normal way. Quite a wide range of emulsions, both black and white, and colour, are available with this system.

A more advanced system uses film completely encased in plastic, the surface of which remains dry at all times. Once it has been exposed, the film is automatically driven out of the camera, and processing commences within its many layers. The sensitive material is protected from the light by a layer of opaque chemical. A few seconds after it has left the camera, the image begins to appear. As the picture forms on the positive sheet, the opaque layer becomes transparent and allows the brilliant colour to emerge. It is not necessary to time development, as the whole process is automatic. Although an acceptable image is achieved in a few minutes, the photograph will continue to increase in intensity for some time. The prints obtained from this system are resistant to damage and the colours are much more permanent than those of the peel-apart material.

Instant cameras of various degrees of sophistication are available, from simple automatic viewfinder models with few controls, to folding reflex types with a small range of accessories. The usual formats are $3\frac{1}{8} \times 3\frac{1}{8}$inch $(8 \times 8$cm$)$, $3\frac{1}{4} \times 3\frac{3}{8}$inch $(8.3 \times 8.6$cm$)$ and $3\frac{1}{4} \times 4\frac{1}{2}$inch $(8.3 \times 10.7$cm$)$, and it must be remembered that these are the dimensions of the final print.

Apart from specialist instant cameras, some larger-format SLRs offer an instant picture back which replaces the normal magazine or camera back. Most 5×4inch camera systems include a device which holds instant film material to be used in place of the normal darkslide. It is then possible to enjoy the benefits of instant pictures and, at the same time, retain the optics, the versatility and the accessories of a conventional high-quality camera system.

Serious photographers tend to use instant cameras simply to take pilot shots in preparation for the actual important exposure. Locations can be researched, and the effects of different conditions of light and weather recorded with very little trouble. Sometimes, however, they have been used to make final, finished prints, even by such an illustrious photographer as Ansel Adams.

Instant cameras are manufactured by Polaroid, Keystone and Kodak.

Pinhole Cameras

These are simple instruments which produce an image by restricting the light entering a box. All cameras, of course, use the same principle, but in the case of a conventional camera diverging light rays are refracted by the lens. They are bent by the air/glass surfaces and made to converge once more. This means that they can be brought to a sharp focus by altering the distance between the lens and the formed image. When a pinhole is used, the light rays continue to diverge so that the image is never absolutely sharp. Nevertheless the smaller the aperture, the sharper the image becomes, and in order to achieve an acceptable picture it is necessary to have a very small and precise hole. This means, however, that the image is very weak, and extremely long exposures are usually required – often ten minutes or more for colour film.

Although it is never absolutely sharp, neither is the image from a pinhole camera completely unsharp. So provided you have a small finely made hole, you can produce a soft picture whose level of sharpness is maintained throughout. You have, in effect, a tremendous depth of field.

The camera itself can easily be made from a small cardboard box (a shoe box is ideal). It should be examined carefully to make sure there are no chinks through which light could leak, and, preferably, it should be painted matt-black inside.

To ensure a precise, regular aperture, the actual pinhole should be made in a flat, smooth piece of aluminium kitchen foil. A small rectangle can then be cut from the centre of one end panel of the box, and the foil taped into position over the hole.

The camera can be loaded in the darkroom by taping a piece of film inside the box on the surface facing the pinhole, then sealing the lid in place with opaque black adhesive tape. A small piece of tape covering the pinhole will act as a sort of shutter until you are ready to make your exposure.

Of course there is no viewfinder, and the composition of your picture will have to be guessed. More accuracy, however, can be obtained by making a second box, as similar as possible to the first, but having the back replaced by a flat piece of tracing paper to act as a sort of viewing screen. If the viewing box is placed in the position to be

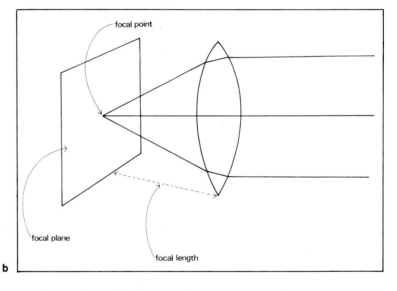

18 The pinhole camera. (a) The image is never completely sharp because the rays of light are not focussed. (b) A lens bends the light rays so that they converge to a fine point, allowing the image to be focussed.

occupied by the camera during exposure, the weak image formed on its screen will give a good idea of what the camera will see.

The length of exposure will have to be determined by trial and error. But if you take careful notes of the results, you should be able to arrive at a rating for any particular emulsion, which will allow you to use an exposure meter to help you to obtain consistent results.

A conventional camera can be converted to

pinhole operation quite simply by removing the lens and covering the hole with black paper on which is a patch of foil containing the pinhole. A 5 × 4inch camera is particularly convenient for this, since a pinhole 'lens panel' can very easily be made, and is rapidly interchangeable with ordinary lenses. The large-format negatives also help to produce a print of higher quality.

By converting an ordinary camera, you can enjoy the benefits of the film transport system or

the preloaded darkslides, and this makes the handling of material much easier. On the other hand, you can put a shoebox camera on any handy rock and let it get on with recording the scene in its own unusual way, while you are setting up your conventional equipment. You have nothing to lose

19 This photograph was taken with a pinhole camera made from a cardboard box. An exposure time of 15 minutes was required in overcast conditions to achieve the image on single weight grade 1 printing paper. The paper negative was then contacted onto grade 2 paper to obtain the positive print.

except a piece of film, and you might achieve a delightful, soft, delicate photograph which exactly conveys the atmosphere of the place.

Panorama Cameras

The panoramic camera has a motor-driven lens which revolves in a horizontal plane and, in doing so, exposes a strip of film (usually 35mm film). The film is held in an arc, so that the distance and angle between the lens and any part of the emulsion remains the same. This produces a long, narrow negative, covering an extremely wide angle of view.

As its name suggests, this camera will enable you to photograph a panoramic scene without suffering the distortion caused by lenses of very short focal length. For, although the angle of view approaches that of a fish-eye lens, the actual focal length of the lens is reasonably long.

Care must be taken in setting the camera up. Spirit levels are usually provided to make sure that the instrument is horizontal. (Even if you wish to experiment with the curious effects of tilting, you need to be able to control matters.)

Stereo Cameras

Stereo cameras produce pictures which, when viewed through special equipment, give the impression of three dimensions. This is done by photographing the scene through two identical lenses which are mounted about the same distance apart as human eyes. Each lens, therefore, has a slightly different viewpoint, and records a slightly different image. The nearer an object is to the camera, the more pronounced is the difference between its two images. Both images are formed, side by side, on the final print. But when this is placed in the stereo viewer, a single picture is seen which gives the appearance of depth.

Although special stereo cameras become available from time to time, a more convenient way to produce stereo photographs is by the use of an adapter. Most 35mm SLR cameras can be equipped with this device, which fits over the normal lens, and uses mirrors to make the two images. The normal 35mm frame is split into two parts, one carrying an image corresponding to that which would be seen by the left eye and the other to that which would be seen by the right. Pictures which contain a distinct foreground, a middleground and a background tend to give the strongest illusion of depth, because the system tends to separate the various planes.

SUMMARY OF CAMERAS

Here again, in brief, are the advantages and disadvantages of the main types of camera.

35mm SLR cameras are easy to carry and to use. They show in the viewfinder exactly what will appear on the film, and exposure is often automated. They frequently form part of a comprehensive system of lenses and other equipment. Film and processing costs are lower per shot. The main disadvantage is that the small negative has to be enlarged to a greater extent, with a consequent loss of quality.

$2\frac{1}{4} \times 2\frac{1}{4}$inch SLRs have the same optical and mechanical advantages as 35mm SLRs, but they are heavier, bulkier and more expensive. The cost of film is greater, but the larger negative makes it easier to achieve prints of high technical quality.

TLR cameras also yield negatives or transparencies of this size. Being mechanically simpler than SLRs of comparable size and quality, they are considerably less expensive. However, the cost of interchangeable lenses, when they are available, is greater because they have to be bought in pairs, complete with shutter. The disadvantages of its viewing system are that the image is laterally reversed, there is no visual check of depth of field and it suffers from problems of parallax.

5×4inch sheet film cameras produce negatives which provide very high technical quality when they are enlarged. These negatives are relatively easy to retouch by hand, and it is possible to process them individually. A very wide range of emulsions is available. Cameras of this type offer great control over the image by 'camera movements,' and usually there is access to an extensive range of lenses and other equipment. The disadvantages of these cameras are that they are heavy and awkward to carry and slow to use. They require tripods and darkslides, and they are expensive both in themselves and in the cost of material.

The use to which you intend to put your pictures will have a bearing on the type of camera you need. If your work is to be reproduced in colour, you might need to be able to provide the publisher with large-format transparencies. Although the rapid advance of technology in the printing industry means that good results can now be obtained from 35mm transparencies or from prints made from 35mm colour negatives, there are still many printers who lack the more sophisticated machinery, and who demand a transparency of at least $2\frac{1}{4} \times 2\frac{1}{4}$inch from which to work, and indeed, some who prefer 5×4inch.

If, on the other hand, your main concern is with producing transparencies for projection, then a 35mm SLR is probably best. Although some projectors are available for larger sizes, there is a much wider range of high quality 35mm equipment. The benefits of the smaller size in storing, filing, handling and transportation are obvious.

LENSES

The lens is the most important part of the camera. It is used to produce a sharp, bright image on the emulsion. And it is an expensive item, since extreme care and accuracy is necessary at all stages in its manufacture. The exact chemical composition of the glass is determined, and each melt checked before it is cast, ground, polished, coated, and each individual element mounted and aligned in the barrel. The tiniest irregularity can result in defects in performance and for this reason you should treat all lenses with great respect. Keep them safe from knocks, do not touch the glass, keep them clean and on no account attempt to dismantle them.

Rays of light reflected from any given point of an object travel in a straight line, but continue to diverge. When a ray of light enters a piece of glass it is refracted (bent) at the air/glass surface, and is further refracted as it emerges. A simple lens is a piece of glass which has been so shaped that it will bend the diverging rays of light in such a way as to make them come together again at a certain point. This is called the focal point, and is the place behind the lens where a sharp image can be formed. The focal plane lies on a line which passes through the focal point at right angles to the optical axis. A camera is focussed by altering the distance between the lens and the film until the surface of the film lies exactly in the focal plane. The nearer an object is to the camera, the greater this distance must be.

Lenses differ in their power to bend light rays. This power is sometimes expressed in dioptres, but is more usually given by focal length. The more a lens bends the light, the nearer to the lens the focal point will be. The focal length of a lens is the distance between the focal point and the lens, when it is set for infinity.

In practice, all but the cheapest of cameras use compound lenses. These employ several differently shaped pieces of glass, each of which will refract the light at its surfaces. The combined effects of all the elements of a compound lens are to produce an image which is free from many of the distortions and aberrations to which a simple lens is prone. The system offers considerable flexibility, so that lenses with particular characteristics may be designed for specific purposes.

The performance of high-quality lenses is further increased by providing the elements with a hard coating to improve light transmission. The effect of this coating is to reduce reflection of light at the surfaces; contrast and colour balance are thereby improved, and flare is minimized.

The aperture of a lens is controlled by a diaphragm. The smaller the aperture, the less light will pass through, and the less exposure the film will receive. The size of the aperture is expressed as an f.number; f1 being the largest.

The best image is formed through the centre of the lens, so the quality of the image tends to improve when a smaller aperture is used. Lenses with a large maximum aperture, therefore, need to be extremely well made in order to maintain the over-all quality of the image. Such lenses are said to be 'fast' and are useful for working in low levels of light. Usually the maximum aperture of a fast lens will be between f2 and f1.4, although some lenses as fast as f1.2 are available.

As the aperture of a lens is reduced, the depth of field increases, so that more of the subject may be in focus. The depth of field is the distance between the objects nearest to the lens and those farthest from it which appear to be in focus at the same time. (This phenomenon is dealt with in chapter 5.) The operation of the diaphragm, therefore, will control both the amount of exposure, and the range of focus.

Most high-quality cameras use interchangeable lenses. Large format cameras have lenses mounted on detachable panels, but other cameras use either screw or bayonet-type mounts.

The mounts of some 35mm cameras are standardized, to allow lenses to be used with various makes. And the products of independent lens' manufacturers are usually available in a variety of mounts.

The focal length of a lens and its maximum aperture is normally marked on the front rim, together with the manufacturer's serial number. For example, the figure 1:.8 f = 50mm would mean that the maximum aperture was f1.8 and that the focal length was 50mm. The same information is sometimes marked more simply as 1.8/50. A zoom lens might be marked 43–86mm 1:3.5, which would indicate a maximum aperture of f3.5

and a focal length which was continuously variable between 43mm and 86mm.

We shall now discuss the various types of lenses. For any given negative format, lenses of different focal lengths will have a different angle of view. Lenses are classified, by this means, into normal (or standard), long-focus and wide-angle.

Normal Lenses

Such lenses have a focal length about equal to the diagonal of the negative for which they are intended; for example, a camera producing 6×6cm negatives has a normal lens of about 80mm, while the focal length of the standard lens for a 35mm camera is about 50mm. In both cases the angle of view is about $45°$, which is roughly the same as that of the human eye.

Long-Focus Lenses

Producing a larger image than a standard lens, long-focus lenses have a narrower field of view. They also have a shallower depth of field. The focal length of this type of lens is at least 85mm for 35mm cameras. The actual physical size of a lens tends to increase with its focal length, so that lenses of 200mm or more can become cumbersome to use. This problem is lessened by the use of a telephoto lens, which is simply a long-focus lens using a special optical system to allow a design which is much more compact (although usually somewhat heavier).

Extremely long-focus lenses of up to about 2000mm are available for 35mm cameras. These can produce detailed, close-up images of subjects which are so far away that they are almost invisible to the naked eye. A reflex system of lens elements and mirrors is usually employed to make them reasonably compact and light in weight.

Wide-Angle Lenses

These have a short focal length, 35mm or less in the case of 35mm cameras, and as the name suggests, they give a wide angle of view. They are useful for photographing a wide sweep of landscape. Their field of view, combined with their greater depth of field, means that they can include objects near to the camera as well as those in the distance, and this can increase the sense of depth in the photograph. They tend, however, to slightly distort the forms near the edges of the frame.

Extreme wide-angle lenses are called 'fish-eyes,' and may have a focal length as little as 6mm, giving a picture angle of $220°$ on 35mm negatives. They have such an enormous depth of field that they need no provision for focussing. Fish-eye lenses will usually record almost everything in front of them, and, in fact, some even see slightly behind themselves. The greater the angle of view, however, the greater is the distortion of the image, and this is often used to create special effects.

Zoom Lenses

Zoom lenses are constructed in such a way as to allow the focal length to be varied without shifting the focal plane, so you can alter the field of view without changing lenses. Once focussed at any focal length, they remain sharp throughout their range. They are available to cover a variety of focal lengths, for example, from 28–45mm in wide-angle or 200–600mm telephoto.

One of the most versatile ranges, however, is from about 35–85mm. This covers everything from fairly wide-angle to medium telephoto.

Macro Lenses

With an unusually great focussing range extending from infinity down to within a few inches of the subject, macro lenses can be used for normal photography or for close-up work without the need for extension tubes or bellows.

Even with ultra-close focussing they maintain a good quality of image, and they usually offer a very small minimum aperture (around f32) to permit maximum depth of field.

Shift Lenses

These are special wide-angle lenses which offer some of the advantages of camera movements enjoyed by sheet-film cameras. The optics can be slid off axis in any direction. This allows some control over the perspective of the image. For instance, when the camera is tilted in order to include the whole of a tall building, the vertical lines of the subject will converge, giving it an unnatural appearance. This distortion can be avoided by shifting the optics to include all the building, while the film plane remains parallel to the subject.

Shift lenses can also be used to make panoramic pictures by taking two photographs from the same place, one with the optics shifted as far to the left as possible, and the other with the optics in the extreme right position.

OTHER EQUIPMENT

Teleconverters

Teleconverters are additional optics which are attached to the back of a lens in order to increase its focal length. They are usually designed to double the focal length of the lens with which they are used. They must, however, be of extremely high quality if there is to be no unacceptable loss in optical performance, and this can tend to make them expensive. Nevertheless, a teleconverter can double the range of your optics for the price of a single component.

Extension Tubes

The closer a camera approaches to an object, the further the lens must be moved from the film in order to focus the image. Monorail cameras usually allow sufficient extension of their bellows to enable close-up photographs to be made, but the focussing range of most SLR camera lenses is far too limited. Indeed, even macro lenses allow only a modest magnification.

One means of increasing the distance between the lens and the film is by the use of extension tubes. These are simply rings which fit between the camera and the lens. They are normally sold as a set of three tubes of different lengths, and, by using them either singly or in combination, it is possible to obtain a range of magnifications.

When the lens to film distance is increased, the amount of light which reaches the emulsion is reduced; and tables giving the increased exposures are normally provided with the tubes. Cameras with TTL metering systems will, of course, compensate automatically.

Camera systems which use automatic diaphragms usually have extension tubes which allow this facility to be retained. And tubes are also available with meter coupling for use with cameras which take exposure readings at full aperture.

Extension Bellows

Extension bellows are another means of increasing the distance between the lens and the film. Their maximum extension is usually considerably longer than a set of tubes, so much greater magnification is possible. They also allow continuous adjustment throughout their range, since the lens is racked along rails in the same way as in large-format, sheet film cameras. In fact, some of the most sophisticated extension bellows incorporate a system of camera movements.

Slight disadvantages of bellows are that they are more cumbersome than tubes, and that, as it is difficult to provide a linkage for an automatic diaphragm, most models must be used with stopped-down metering.

Filters

Filters are pieces of transparent material (usually optical glass) which absorb a certain part of the light passing through them. They are fitted into a metal collar which screws into place in front of the camera lens.

The colour of daylight varies considerably; for instance, according to the time of day. The human brain is able to compensate automatically for these changes, but colour film is balanced for a particular colour temperature. Filters are available to correct errors which are due to variations in the colour temperature of the light source.

Even films balanced for artificial (Tungsten) light can be used in daylight if the correct filter is employed.

Under certain circumstances, black and white films also require correction by filters because they respond to various colours in a different way from the human eye.

Unwanted reflections from non-metallic surfaces, such as glass or water, can be eradicated or reduced by a polarizing filter. Filters which absorb ultra-violet light are used to reduce haze, and often such filters are left on the lens as a permanent protection against dirt and damage.

Filters are also available to produce a wide variety of special effects.

Lens Hood

If extraneous light is allowed to fall onto the surface of the lens, it can reduce the contrast of the image. A lens hood (or shade) is used to prevent this, and also to provide extra physical protection for the front element of the lens.

Tripod

A large-format camera will be used on a tripod virtually always. However, it is essential to support even a 35mm camera for exposures longer than about 1/30 second. The longer the exposure, of course, the greater the risk of camera shake. Also, the longer the focal length of the lens, the more difficult it is to hand-hold the camera; not only is the size and weight of the lens itself greater, but with a long-focus lens, the slightest movement is greatly exaggerated.

Apart from the occasions on which it is absolutely essential, the use of a tripod will allow a greater choice of exposure time, and, therefore, of aperture and film speed and type.

The best sort of tripod for landscape photography is one made of light alloy. Unfortunately the lightest tripods available are not firm enough, and you will need a reasonably robust model which will be heavier to carry. The legs should be individually adjustable, so that it can be set firmly on uneven ground, and there should be a centre column which may be moved up and down to adjust the height without having to disturb the legs. A pan/tilt head should be fitted to the tripod, so that the camera can be held firmly in any position.

Cable Release
Even when a camera is mounted on a tripod, it is very easy to cause it to move slightly when you press the shutter release button. A cable release screws into a socket on the release button, and allows you to fire the shutter without the movement of your hand being transmitted to the camera. It is fairly inexpensive, and should always be used with the tripod to minimize the risk of camera shake.

Exposure Meter
Unless the camera has a built-in meter, a separate exposure meter is an essential item of equipment. There are two main types in current use: the selenium cell and the photo-resister. When light falls on the selenium cell it generates a small electric current which moves a galvanometer needle: the more light, the greater the current and the farther the needle moves across the dial. This type of meter does not require a battery.

The other type employs a substance such as cadmium sulphide (CdS), whose electrical resistance changes with the amount of light falling on it. This resistance is used to alter the current produced by a small battery; the variations in voltage being recorded either by a needle on a scale or by a digital read-out. This system is extremely sensitive and gives accurate results even in conditions of low illumination.

Readings may be taken either of the light reflected from the subject, or of the light which strikes it (incident light). When the reading has been obtained, a calculator on the meter will give the shutter speed required at any aperture for the particular ASA rating of the film in use.

20 Weston exposure meter.

Types of Film
Films vary considerably in their sensitivity to light, and this difference is expressed in terms of speed – the faster the film, the more sensitive is its emulsion. Various systems have been devised in order to classify films according to their speed. The arithmetical system of the American Standards Association (ASA) has been followed by the British Standards Institution, and is generally accepted in Britain and the United States, while the DIN (Deutsche Industrie Norm) logarithmic method is popular in Europe. The faster the film the higher its rating.

Slow films are rated from about 25ASA (15DIN) to 64ASA (19DIN). Films between 64ASA and around 200ASA (24DIN) are considered to be of moderate speed. And fast films are rated from about 200ASA to 400ASA (27DIN). Some ultra-fast films are available up to about 1600ASA (32DIN).

It is, of course, essential to take into account the speed of a film when calculating exposure.

In general, slow films have a finer grain and produce more contrast than fast films. The main advantage of faster films is that they require less exposure and may, therefore, be used in poorer

light conditions. Or, given the same conditions of light, a smaller aperture may be employed, thus increasing the depth of field. Fast films, however, are less well able to resolve detail, and they have a greater tendency to graininess.

Virtually all black and white films used for general photography are panchromatic, that is to say that they are sensitive to all colours in the visual spectrum. Their response to colours differs, however, from that of the human eye, and occasionally corrections may be made by the use of filters.

Colour films tend to be rather slower than black and white. They are of two main types: reversal and negative. Reversal films yield positive transparencies, whereas negative film produces negatives from which positive colour prints are made.

All colour films are balanced for the colour temperature of the light source. Daylight film is balanced for sunlight at noon, and types A and B for artificial light. When used in daylight, artificial light films have a strong blue cast, and for this reason they are occasionally employed in landscape photography, in order to achieve a particular effect.

Infra-red films are sensitive to infra-red radiation as well as to visible light. They may also be used to achieve unusual effects in landscape photography. Strange contrasts are produced, and features are seen in great clarity in spite of mist or distance. A focus shift is sometimes necessary when working with these films, since the focal point for infra-red is slightly more distant than that for visible light.

SUMMARY OF EQUIPMENT

Here are some suggestions for choosing equipment.

1 You should consider the sort of pictures you intend to take. (If in doubt, choose the most flexible system – 35mm.)

2 The camera you buy now may, in the future, form the basis of a complete system.

3 Your work will be made much easier if, with a little experience, you are able to use your camera almost without thinking. So before buying, try to handle several cameras of the type you require. See which suit you best, which feel right, which have the controls placed most readily to hand.

4 You should buy the highest quality equipment which you can afford.

5 Buy as little ancillary equipment as possible. The more unusual items, which are required only rarely, can be hired. Spend your money on higher quality basic equipment.

3 Processing

So far, the rapid development of technology in the photographic industry seems to have had its greatest effect in the design of camera equipment. Nevertheless, the processing of photographic material will soon, no doubt, be subject to similar technical innovations; and we can look forward to inexpensive automated equipment. Until that time, however, most of us must stick to the traditional darkroom procedures. And perhaps they will continue to give us greater control over our medium than the instant, electronic devices of the near future.

THE DARKROOM

A room devoted entirely to the processing of photographs provides enormous benefits. Even if it is only a tiny area partitioned off from a larger room, and even if it is without running water, it is immeasurably better than having to convert a kitchen or bathroom.

The smaller the room, of course, the more carefully it must be organized. A wet area and a dry area should be established. The dry area contains the enlarger and is used for exposing prints, loading exposed films into developing tanks or hangers, and, in fact, for all operations involving negatives and papers while they are dry. The wet area is where the chemical processes are carried out, and great care must be taken to prevent the dry area being contaminated by even the smallest trace of any of the solutions.

Obviously the darkroom must be completely lightproof. This can only be judged when your eyes are attuned to the darkness, and checks should be made when external lighting is at its brightest. When all outside light is excluded, there is no point in having black walls and ceiling; in fact, the lighter they are painted, the better, since they will simply reflect the safelight.

The room should be well ventilated and, if possible, there should be some means of control-ling the temperature.

The safelight must be placed so that it gives good illumination of the processing sink without being too close to the light-sensitive materials. It should not shine directly onto the baseboard of the enlarger, as this will make composition and focussing difficult, and may even influence the readings of the enlarging meter or colour analyser. In fact, it is better to switch off the safelight while the enlarger is being operated, and this can be accomplished automatically by wiring them both through a special switch.

The enlarger itself should be mounted on a very firm bench, since even a slight vibration during exposure can result in loss of sharpness.

Ideally, the wet area of the darkroom should be equipped with a long, rectangular sink. This should be made of ceramic, stainless steel, or a suitable plastic. Dishes and large containers of chemicals are usually stored under the sink on wooden racks.

There must be, of course, some means of regulating the temperature of the chemical solutions, and a thermostatically controlled mixer-tap will save a lot of trouble. Alternatively, an immersion heater may be used.

Extreme care must always be taken in the darkroom to avoid dust, dirt and chemical contamination, and to keep dampness from the dry area; for this reason an adequate supply of dry towels (preferably disposable paper towels) should be provided. A large waste-bin is necessary, to take the considerable amount of rubbish which tends to be generated.

The Enlarger

As with camera equipment, you should buy the highest quality instrument you can afford. Again, the lens is the most important component. The time, trouble and expense of producing a superb negative will all be in vain if the image is then to be

In these pictures the strangeness of the moorland is emphasized by shooting on Tungsten-type film to produce a range of cool blues. Although only details of the landscape are shown, the atmosphere of the place is evoked by the abstract image.
John Williams

This photograph was taken in the morning sun, so that the shadows helped to reveal the unusual forms of the hills. Since light at this time of day tends to produce warm reddish tones, a blue filter was used to preserve the coolness of colour which is characteristic of limestone country. *John Williams*

projected through poor optics in the enlarger.

Enlarger lenses are specially designed with flat field characteristics. They do not have a shutter but are equipped with a diaphragm to control the aperture. Although apertures are marked, either in f. numbers or as exposure ratios, the diaphragm control has very positive click stops, and is usually set by feel. Various focal lengths are available, each designed for a particular negative format. For example, a lens for 35mm negatives would have a focal length of about 50mm; 6cm sq. negatives would use a 75 or 80mm lens, and a lens of about 135mm would be used for 5 × 4inch negatives.

There are two main types of enlarger: condenser and diffusion. To ensure even illumination of the negative, condenser enlargers use a set of simple lenses called 'condensers,' which are inserted between the lamp and the negative. Although a certain amount of adjustment is possible by moving the lamp up or down in the lamphouse, condensers have to be changed when the enlarger lens is changed or when there is a great variation in

21 Durst C35 enlarger. An example of an enlarger suitable for colour and black and white prints, without any additional accessories, up to a maximum of 11 × 15inches.

the scale of enlargement.

The other type of enlarger often uses a cold cathode grid to provide a high-power diffused light source. This has the advantage of requiring no adjustment, whatever the focal length of the lens or the size of the enlargement. It also helps to suppress the effect of dust or marks on the negative.

Filter packs can be fitted to some enlargers for colour printing. Others are equipped with a colour head which uses a stepless system of filtration. This is particularly convenient; extremely accurate adjustments being made simply by turning the control knobs.

The degree of enlargement is controlled by moving the head of the enlarger up or down the column, and the image is focussed by adjusting the distance between the negative and the lens. With some enlargers the image may be projected horizontally, either by turning the head or by using a mirror projection system. In this way, the throw can be increased, and a much greater magnification obtained.

Many modern enlargers incorporate a system whereby the distance between the negative and the lens is automatically adjusted as the head moves up or down the column. By this method, the image remains in sharp focus, whatever the scale of enlargement.

High-quality enlargers are made by Omega, Durst, De Vere and Besseler. Lenses of extremely fine quality are made by Nikon, Leitz and Rodenstock.

Other Darkroom Equipment

A large, clear darkroom clock which shows minutes and seconds is essential. A timer which can preset to switch the enlarger on and off for any exact time of exposure will be found to be a very useful item but is not vital. Similarly, an exposure meter for enlarging, and a colour analyser can save time and trouble.

For the wet side of the darkroom, dishes of various sizes will be needed, along with measuring cylinders, jugs, tongs and a thermometer. Expanding containers will be useful for storing expensive chemicals such as colour developers, which are damaged by oxidation. These can be compressed so that the size of the container is reduced as the liquid is used up, and air is thus excluded. A processing drum will be required for colour prints, and, if possible, a washing tank should be provided.

Desirable items, not necessarily to be housed in

the darkroom, would be a drying cabinet for films, either a rotary or a flat-bed print drier and a light-box for evaluating negatives and transparencies, and for retouching. A dry-mounting press, a tacking iron and a print trimmer would be useful equipment for mounting and presentation.

Although we have described something of an ideal set-up, it is perfectly possible to produce good results with much less equipment, and in much less convenient accommodation. You can improvize almost anything except a high-quality lens. However, care, method, cleanliness and accuracy are absolutely indispensable and they are usually much more difficult to exercise in trying circumstances and with limited equipment.

DEVELOPING BLACK AND WHITE FILMS

When a film is exposed in the camera, the light focussed through the lens onto the emulsion causes a chemical change in the grains of silver salts onto which it falls. This forms an image, called a *latent* image, since it is not yet visible. At this stage, the emulsion is still sensitive to light, and development must, therefore, take place in darkness. The most convenient method of accomplishing this is to load the film into a light-tight tank so that the operation can then be carried out in the light.

To make the latent image visible, the film is immersed in a solution of chemicals, known as a developer, which converts the silver salts into black metallic silver. Those grains which have been affected by the exposure to light are converted much more rapidly than the rest, and development is carefully timed so that it is stopped before the unexposed grains begin to change. The film is then put into a chemical fixer which renders the remaining unexposed silver salts soluble in water, so that they can be removed in the final wash, leaving a black visible negative image on a transparent support.

Loading the Tank

Large, rectangular tanks are available for processing sheet films. The films are clipped into stainless-steel hangers and suspended in the solution. Separate tanks are normally provided for each stage of the process, the light being switched off while the films are transferred from one tank to another at the appropriate time.

35mm and roll films are loaded into plastic or stainless-steel spirals which are then placed either into the large rectangular tanks or into individual cylindrical ones. The individual tanks have a light-trap which enables the various solutions to be poured in or out without light being able to reach the film.

22 The minimum equipment needed to develop a black and white film: developing tank and spirals, measuring cylinder, thermometer and bottles of concentrated developer and fixer.

The films must, of course, be loaded into the spirals in darkness, and great care should be taken during this operation. Your hands must be clean and perfectly dry. As far as possible, handle the film by its edges and avoid touching the emulsion – scratches, dirt and contamination from greasy fingers can cause permanent damage to your negatives. The first few inches of 35mm film (the leader), which is shaped to facilitate its attachment to the take-up spool of the camera, should be trimmed off by a clean right-angled cut between sprocket holes. With roll film, the backing paper is unwound until the end of the film is reached.

The film is then fed into the spiral, taking care to avoid kinks which can cause marks on the negative. Plastic spirals are usually loaded from the outside, while the stainless-steel type are often loaded from the centre outwards.

When loaded, the spiral is inserted into the empty tank and the lid put on. The rest of the procedure may then take place in the light.

Prepare the correct amounts of chemical solutions – greater accuracy can be obtained by preparing the chemicals in measuring cylinders and standing both these and the developing tank in a water bath which is maintained at a constant 68°F (20°C).

Developing

A good general purpose developer such as Kodak D76 or Ilford ID11 should be used to give standard results. It should be made up to the manufacturer's recommended dilution, and brought exactly to the right temperature, which will usually be 68°F (20°C).

The developer is then poured quickly into the tank and the timer is started. The tank should then be tapped and agitated to remove air bubbles. To ensure even development, frequent agitation is essential, so that fresh developer is constantly being brought into contact with the emulsion. This is usually performed every 30 seconds during development, and is achieved either by inverting the tank or by rotating the agitation rod for 5 seconds. Films in the large tanks are agitated by removing the lid (in darkness, of course), and raising and lowering the hangers and spirals in the developer.

Manufacturers recommend development times for various types of film, and these should be followed exactly. As soon as the time is up, the developer is poured out of the tank and the stop bath is poured in.

The Stop Bath

Most developers are alkaline and fixers are acid, so any developer which is carried over will contaminate the fixer and reduce its efficiency. Films, therefore, should be rinsed in water before they are immersed in the fixer. Better still, an acid stop bath can be used to stop development and to neutralize the developer. This has the advantage of keeping development time accurate and giving greater protection to the fixer. As soon as the stop bath has been poured in, the film is agitated and left in the solution for one minute.

Fixing

The last solution to be poured into the tank is the fixer. This clears the unexposed parts of the emulsion by rendering the silver salts soluble in water. Fixing time is usually about 5 minutes and, again, the film should be agitated from time to time to ensure even and full treatment. The timing of this procedure and the temperature of the solution are not as critical as those of the development stage. Nevertheless, the temperature of the fixer should be within about 3°C of that of the developer, and excessively prolonged immersion should be avoided as this may result in bleaching of the image.

Although care should be taken to ensure that the film remains in the fixer for the full time, it may be removed after about one minute for a brief examination in the light.

Washing

After fixing, the film must be washed in running water for about 30 minutes. Resist the temptation to skimp this stage of the process – if washing is not thorough, chemical compounds may remain on the film, and may, in time, cause serious damage to the image.

At the end of the washing period, a few drops of wetting agent may be added to the water to promote even drying.

Drying

Sheet films are left in their hangers, but 35mm and roll films are removed from their spirals, and plastic or stainless-steel clips are attached to each end. Drying can be accelerated by using squeegee tongs to remove the surplus water, but this must be done with a great deal of care, as the emulsion is easily damaged while it is wet. The films are then suspended in a suitably clean area. It is very important that they are protected from any dust

and dirt at this stage, and the best place for them is in a heated drying cabinet which has been designed for the job.

When they are completely dry, they are dusted with canned air or a blower brush, and put into protective bags, 35mm and roll-film negatives being first cut into convenient lengths.

COLOUR FILM PROCESSING

Colour films vary a good deal in their processing systems. Although some use procedures which are too complex to be undertaken except in specialized laboratories, it is possible to process many of them in an ordinary darkroom.

The number of stages in the sequence, the temperature of the solutions and the processing times differ widely from one system to another, and it is necessary to follow the manufacturer's instructions for the particular system you use.

Even more care and accuracy is necessary for processing colour films than for black and white. Temperatures, which tend to be higher, are more critical; sometimes requiring to be controlled to within $0.25°$C. The work should be very methodical. All solutions should be prepared beforehand and maintained at the correct temperature. The manufacturer's recommendation as to process times and periods of agitation should be followed exactly.

Rubber gloves must be worn when handling all chemicals – they tend to be more noxious than those for black and white, and some are toxic.

4 Printing

BLACK AND WHITE FILM PRINTING

A wide range of black and white papers is available. The papers vary in the size, thickness and colour of the base, in their surface texture, in their speed and contrast, and in the colour of the image.

'Single weight' and 'double weight' are terms used to describe the most common thicknesses of paper. Single weight is quicker to dry and easier to glaze. It should be used for prints which are to be pasted up for reproduction. Double weight, being more substantial, is normally used to make prints for exhibition.

The colour of the actual paper base is normally white or cream, but some papers are available in primary and other vivid colours. The image colour varies slightly, some blacks being warmer or cooler than others.

Paper is made in a range of surface textures from matt to glossy. Glossy paper, when it is glazed, gives a very deep black and a good rendering of fine detail. The more matt a paper is, the easier it is to retouch the print, but the less intense are its blacks.

RC (resin-coated) or PE (polyethylene) papers have a waterproof base. This means that the base will not absorb any of the chemicals during processing, and washing time is, thereby, greatly reduced. Another advantage, if you don't possess a print drier, is that they will dry naturally to a high gloss finish without creases or wrinkles.

Printing papers are manufactured in several grades of contrast. The usual range being from grade 1 to grade 4 (although some of the more popular types of paper are also made in grade 0 and grade 5). Grade 1 is soft, grade 2 is normal, grade 3 is hard, and grade 4 is very hard. The harder the paper, the more contrasty will be the image obtained from any particular negative.

Colour printing paper, like colour film, contains three layers of emulsion, and is sensitive to all visible colours. It is available in only one grade, but this is of no consequence since the importance of tone is much reduced in the presence of gradations of hue. Colour paper must be handled in absolute darkness until it has been processed, but most black and white papers may be viewed with an amber safelight.

Contact Prints

A simple way of obtaining a print is to place the negative in close contact with the emulsion of the printing paper, to expose it to light and then to process the paper in the normal way.

Contact prints are, of course, the same size as the negative, and they are normally used only for assessment and reference. If only a small picture is required, however, this method may be used with large-format negatives to produce the final print. Since there is no enlargement, the quality can be very high indeed.

A convenient way of producing a sheet of contact prints is to use a printing frame. This is simply a device which holds the negatives and the paper in perfect contact under a sheet of glass. The light passes through the glass, then through the negative and onto the emulsion of the paper. Both the glass of the frame and the negatives must be perfectly clean. The negatives should be handled only by the edges, and should be dusted with a blower brush before they are put into the frame. The printing paper is inserted into the frame so that its emulsion is in contact with the emulsion side of the negatives; the frame is then closed and placed under the enlarger.

In contact printing, the function of the enlarger is simply to provide a controlled source of light. The lens of the enlarger should be closed down a couple of stops and, in the first instance, an exposure of ten seconds should be made. The paper is then removed from the frame and processed. If necessary, further prints should be made to correct over- or under-exposure.

23 The same negative printed on different grades of paper. (a) Grade 1. (b) Grade 2. (c) Grade 3. (d) Grade 4.

c

d

55

Sheets of contact prints are normally prepared to show every exposure which has been made. They are used to help the photographer to decide which pictures to enlarge and how to crop them. They also provide a useful record when filed with the negatives.

24 To make contact prints, the negatives are placed in position in the frame with their emulsion side facing the emulsion of the printing paper. The glass is then lowered to hold them in close contact, and an exposure is made under the enlarger.

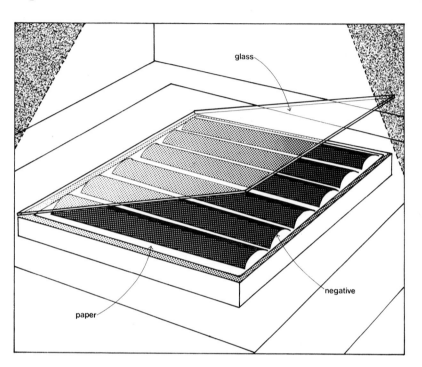

glass

negative

paper

Making Enlargements

Chemicals for processing the prints should be made up to the recommended dilutions and brought to the working temperature of 68°F (20°C). Dishes made of plastic or stainless steel are used, and should be large enough to hold a generous amount of the solution. The dish holding the fixer is often larger than the others, since it will be required to hold several prints at the same time. The first dish contains a print developer, the second a water rinse or stop bath and the third holds the fixer. A means of washing the prints is required, and this should be either a purpose-made washing tank or a vessel which is large enough to hold a good volume of water and which can be refilled repeatedly.

The negative which has been selected for en-largement is cleaned with a blower brush, and fitted into the carrier, emulsion-side down. The carrier is then replaced in the enlarger, which is adjusted until a sharp image of the desired size is

projected onto the masking frame. The size and shape of the mask can be set so that it will frame either the whole of the image or that part of it which is to be printed. This operation is best done with the light out, and with a magnifier to ensure absolute sharpness.

The Test Strip

The next stage is to make a test strip to determine the exposure. A strip of printing paper is placed across a part of the image which is typical of the whole. Most enlargers have a red filter which can be swung in front of the lens so that the strip can be positioned accurately without being exposed to the white light. The enlarger lens is then stopped down, the filter removed, and an exposure made. A piece of card is used to shield part of the paper during exposure, and this is moved at 5-second intervals so that the strip is exposed in a series of steps of increasing time. A typical strip might show five different exposure times, say 5, 10, 15, 20

and 25 seconds. The strip is then processed, and the most appropriate exposure assessed. Development time (usually 2 minutes) must be kept constant throughout the printing procedure. Much more accurate judgements can be made if the strip is examined in daylight.

25 Test strips. When the paper is developed it shows the effect of exposures of 5, 10, 15, 20 and 25 seconds' duration. A full sheet of paper is not essential; a narrow strip is normally used, but this must be carefully positioned in an important part of the image.

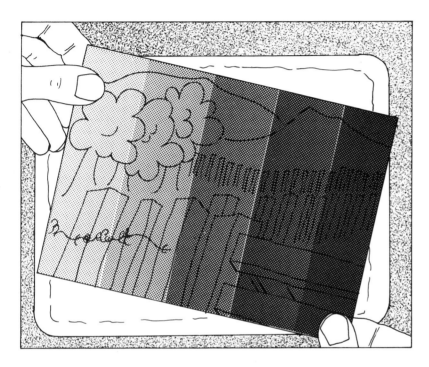

Exposure

When the correct exposure has been determined, a full-size print can be made. This is most easily and accurately done by inserting a piece of printing paper into the masking frame, and setting an automatic timer to the required time. The timer will then switch the enlarger on and off to give the exact exposure.

If, when the print is processed, some parts of it are too light or too dense compared with the rest, the negative is reprinted, and during exposure the appropriate parts are either 'burned in' or 'held back.'

Burning in means that light parts of the image are given extra exposure time after the normal exposure has been completed. This is best performed by cutting a hole in a thick piece of card, and holding this between the enlarger lens and the printing paper so that the only light reaching the emulsion is that which passes through the hole and on to the selected part of the image. A blurred image will form on the card itself if it has a light surface, and this helps accuracy.

Unduly dense parts of the image may be given less exposure than the rest by shading them with the hand or with a dodger during the normal exposure time. A dodger is a simple instrument made by attaching a small opaque disc to a piece of thick wire. It is used for accurate holding-back of small areas, particularly those in the centre of the image. The actual period of shading of the print must, of course, be carefully timed. And if the total time of exposure is short, accuracy may be difficult. In this case, the lens of the enlarger should be closed down an extra stop so that the exposure time can be doubled. In order to avoid sharp edges, hands or tools for holding back or burning in should constantly be in slight motion during the whole time they are in use.

a

26 Selected areas of the print may be given more or less exposure by the use of simple tools. (a) Shading by hand. (b) A card cut to required shape gives an accurate outline. (c) A 'dodger' allows small areas in the middle of the print to be 'held back.' (d) Using a hole in a card which will give extra exposure to a particular part of the image.

c

b

d

Processing

The paper is immersed in the developer for 2 minutes, the liquid being agitated by gently rocking the dish. When the time is up, it is transferred to the stop bath and then to the fixer. Plastic tongs are used to handle the print, and it is important to use fresh tongs for each solution, in order to prevent contamination. Fixing time is usually 5 or 10 minutes, but the main light may be turned on after a couple of minutes to examine the print in the fixer. Fixed prints must be washed thoroughly. Unlike film, the paper base will absorb some of the chemicals, making it necessary to wash prints for at least an hour. (RC papers are an exception, they have a waterproof base and require a much shorter washing time.) If, during the washing period, another print is added to the tank, the water will be contaminated and washing will have to start all over again. For this reason, prints are usually washed in batches, being kept in the fixer until they are ready.

The darkness or lightness of a print is determined by the amount of exposure, the dilution and freshness of the developer, the development time and by the temperature of the solution. It is much easier to control the process and to repeat results if only one of these factors is varied. Printing, therefore, is usually controlled by adjusting the exposure, while keeping all the other conditions constant.

Drying

When the prints have been washed thoroughly, they are dried on a flat-bed or rotary print drier. Glossy paper may be glazed by pressing it with a squeegee face-down, into close contact with the polished metal sheet of the drier. If a high gloss is not required, the print is simply put into the drier with its back to the metal sheet.

Another method of drying is to simply place the prints face up on absorbent paper and allow them to dry naturally. RC papers are particularly suited to this method.

COLOUR PRINTING

There are two ways of printing colour negatives – the additive system and the subtractive system. With the additive method, three separate exposures are made, each through a different coloured filter. Red, green and blue filters are used, since these are the primary constituent colours of white light. The times of the three exposures are varied until a satisfactory result is obtained.

In the subtractive system, the light from the enlarger is adjusted by filtering out different amounts of its constituent primary colours. The best method of doing this is by the use of an enlarger with a colour head, which enables the various values to be set, simply by turning a knob. Otherwise, a set of filters of various densities of yellow, cyan and magenta is used. These are made up into a pack and inserted into a drawer in the enlarger. The correct amount of each colour to be filtered out is determined, either by test strips or by the use of a colour analyser.

Although the equipment is more expensive, this system has the advantage of requiring only one exposure, and printing can be controlled by burning in or holding back.

Manufacturers produce colour papers which are designed for use with their particular negative film. There is also a system (Cibachrome) for producing very high quality colour prints from transparencies. As with colour films, the processing of colour prints is more complex than that of black and white. The processing times and the temperatures of the solutions are, again, more critical, and the manufacturer's instructions should be followed exactly.

Since the paper is sensitive to all colours, the first stages of processing must be carried out in complete darkness. However, light-tight processing drums are available, which are similar to developing tanks for films. They are used in much the same way, except that they are continually rolled backwards and forwards during processing. More sophisticated models are motor-driven and have a precise temperature-control system.

5 Photographic Techniques

The greater mastery a photographer has over technique, the more control he has over his medium, and the more closely he will be able to match the final results with his original ideas. Proficiency, of course, comes with practice and experience, and to the novice, the technical aspects of photography often appear daunting in their complexity. But there is no need for anxiety. Even without the use of automated equipment (and some modern cameras will even focus themselves), it is fairly easy to produce acceptable and repeatable results by following a few simple procedures.

Photography, like painting and drawing, is merely a process, simply a means to an end. There is no particular virtue in any of these crafts in themselves; they are useful only insofar as they allow the artist or designer to make his point. The important thing is to try to make pictures which say what you want them to say: pictures which record facts or induce feelings, which evoke atmosphere or help us to see something new in a familiar place – pictures, in other words, which communicate. That is the most difficult, the most exciting and the most frustrating job of all. Do not attempt to learn all the techniques first, so that they can be applied when the serious business begins. Too much concern with technical matters will distract you from the really important issues. And, in any case, there is nothing more irksome than doing mechanical exercises when all you want is to make pictures. Techniques can be kept very simple until you gain confidence. Then, with increasing experience in dealing with the difficulties of aesthetics and of communication, will come an increasing desire for more control over the image. From time to time, you will need to perfect a certain technique in order to solve a particular problem. And, because you need that technique, you will tend to learn it more easily and to understand it better. The more difficult techniques will not then be seen as obstacles, but as opportunities to obtain exactly what you want in a picture.

This way of working will help you to continue to learn, and you should not be limited by what are considered to be the acceptable procedures – when you understand the fundamental principles, you can try to find your own ways of doing things. In any case, frustration in not being able to produce precisely what you want is a constant spur to progress.

CONTROL OVER THE IMAGE

The importance of technique lies in the control over the image which it affords. It is often a matter of composition in the broadest sense: of how one may exercise selectivity, organize and order the various elements – emphasizing some and playing down others.

Everything which appears in a picture makes a point; it 'says' something (whether we want it to or not) and it affects everything else in the picture. If the point it makes does not actually help the artist's intention, then the chances are that it is not merely superfluous but that it is actually detrimental. It will probably detract from the force of his statement, or, worse, conflict with it.

In general, control in photography may be exercised at both the taking and the processing stages. At the taking stage, the most critical means of controlling the image is the selection of viewpoint, and the timing of the shot – that is, the choice of exactly the right time of day, or even the right time of year or weather conditions, in order to get the quality of light which is required.

The difference between a snowbound winter landscape and the same place illuminated by a hot midsummer sun, or seen through mist, is quite apparent, and the qualities of one or the other may be used by the photographer to make his point. However, less obvious changes can exert a subtle influence over the subject; the light at sunrise and

sunset for instance, is of a different colour temperature from that at midday, and colour film, being balanced for noon sunlight, will record a much warmer, reddish scene. Also, at the beginning and end of the day, and at certain times of the year, the sun will be low, and this will accentuate texture and form. In fact, a landscape can change completely when it is illuminated from different directions as the sun moves around the sky. It is up to the photographer to observe, to anticipate and to calculate these effects.

With regard to the position of the camera, it is important to try out a number of different viewpoints, even if the first seems to be satisfactory. And in dealing with this, the viewfinder of the camera can be useful in that it enables you to concentrate on the part of the scene in which you are interested, cutting out all the surrounding features. However, it is necessary to develop the ability quickly to perceive *everything* which appears in the viewfinder. This may sound obvious, but it is suprising how easily the beginner can overlook the most intrusive object. When you stand and look at a scene, your eyes and brain automatically concentrate on those features which are of interest to you. The camera is not able to be so selective; it will record everything towards which it is pointed. And when you process the film you may be surprised to see, say, the front of a car intruding into the foreground. At the time of taking the photograph, you had been looking only at what you wanted to record, and had unconsciously ignored that which was irrelevant to your intentions – but the camera hadn't. It is very easy to overlook details, and it is, therefore, essential to train yourself to make a conscious effort to check everything which will appear in the photograph.

DEPTH OF FIELD

Each point of light from the subject is recorded on the film as a tiny disc, or 'circle of confusion.' The smaller the circles of confusion, the sharper the picture; and they will be at their smallest when receiving light from the point at which the lens is focussed. However, objects nearer to, and farther away from, the camera than this point will appear to be in focus, provided the circles of confusion have a small enough diameter. The exact limits of acceptable sharpness will, of course, depend on the degree of enlargement of the negative or transparency.

Depth of field is the distance between the objects nearest to the lens and the objects farthest from it, which appear to be in focus at the same time. This area of acceptable sharpness can be extended or contracted by various means, giving considerable control over what is and what is not in focus in a photograph.

When you look at a complex scene with many elements at varying distances, your eyes do not focus on the whole range of foreground, middleground and background at the same time; they 'accommodate,' that is to say, shift focus rapidly from one distance to another. In this way, you are able, virtually without conscious effort, either to get the impression of the whole scene, or to concentrate on certain parts. In photography, on the other hand, the range of clarity in any particular picture remains static, and you must decide what effect you wish to achieve. By controlling the depth of field you can make everything from the foreground to the horizon appear sharp, or you can focus only on a particular feature, which would otherwise be lost in a wealth of sharply defined detail. You can choose just how much of the foreground, the middleground or the background you wish to see, and throw the rest out of focus.

Depth of field depends on the aperture of the lens and the size of the image. The small apertures, f16, f22 or f32, for example, give the greatest area of sharpness, while large apertures such as f1.4 or f2 give a much shallower depth of field. Obviously the shutter speed must be adjusted to give the correct exposure for the f. number selected.

The size of the image is determined by the distance between the camera and the subject, and by the focal length of the lens. The closer the camera approaches the subject, the larger the image and the shallower the depth of field. Similarly, long-focus lenses magnify the image, thereby reducing the depth of field, but lenses of short focal length tend to provide a large zone of sharpness. The image made by a fish-eye lens is usually so small that it produces a tremendous depth of field, rendering everything sharp even at large apertures – indeed, some fish-eye lenses do not even need to be focussed.

When taking any photograph, whatever the circumstances, it is important to know what the depth of field is likely to be. With many cameras it is possible to see on the focussing screen how much of the picture is sharp. The image in the viewfinder of an SLR camera fitted with an automatic diaphragm will always be formed with the lens at maximum aperture, whatever f. number is set. In this case, a pre-view button is usually fitted which

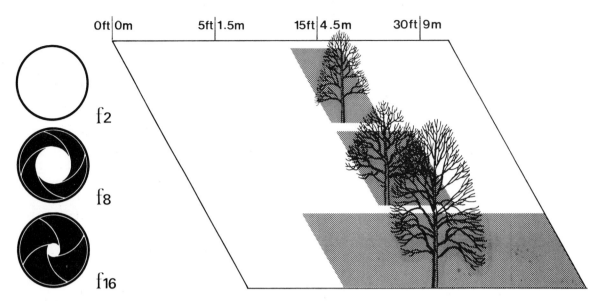

27 Changing aperture: When the lens is stopped down (i.e. from f2 to f16) the size of the aperture is reduced, and the smaller the aperture, the greater the depth of field.

will stop down the lens to the selected aperture in order to allow a visual check of the depth of field to be made.

It is also possible to work out the depth of field from the scales provided on the lens barrel. These show the distance (usually in both feet and metres) to which the lens is focussed, and the distances behind and in front of this point which will be sharp at any given aperture. This method of calculation is particularly useful in lower light conditions, or when planning to get the whole sweep of landscape sharp at the same time; and in the case of such cameras as TLRs, which have no provision for a visual check, it is the only practical way of making an estimation.

Although you should try to decide the range of sharpness in all your shots, the most obvious example of the exploitation of depth of field is the isolating of a particular detail by throwing everything else out of focus. In order to do this with a standard lens (a 50mm lens, for example, on a 35mm camera) you will have to approach quite close to the subject and use a large aperture – probably the maximum aperture available. However, it becomes easier to obtain a differential focus the longer the focal length of the lens. With a 500mm lens, for example, a fairly distant object can be focussed, and the depth of field will still be shallow enough to put the background and fore-ground out of focus, even at a small aperture.

Conversely, of course, the longer the focal length the more difficult it is to get everything sharp, even with the diaphragm stopped right down. So the easiest way to achieve over-all sharpness is to use a wide-angle lens. With a standard lens you will probably find, when it is set for infinity and stopped down to the minimum aperture, that while the background will be sharp, the foreground and perhaps some of the middle-ground will still be out of focus. To overcome this problem, you can make use of the area of sharpness which lies behind the point on which the lens is focussed. Except in close-up work, there is about twice as much depth of field behind the focussed point as there is in front of it, and in the case of a lens focussed on infinity, this is all wasted. If, however, the lens is refocussed so that the most distant objects are just within the zone of acceptable sharpness, much more of the picture will appear to be in focus. The point at which the lens should be focussed is called the hyperfocal point, and it is fairly easy to find. First, set the lens to infinity and then find the nearest point to the camera which appears to be in focus at the aperture you intend to use. With most cameras you can do this visually, but it is often quicker and more accurate to refer to the depth of field scale on the lens barrel. This nearest sharp point is the hyperfocal point, and the

Wide aperture (e.g. f2)　　　　　　Small aperture (e.g. f16)

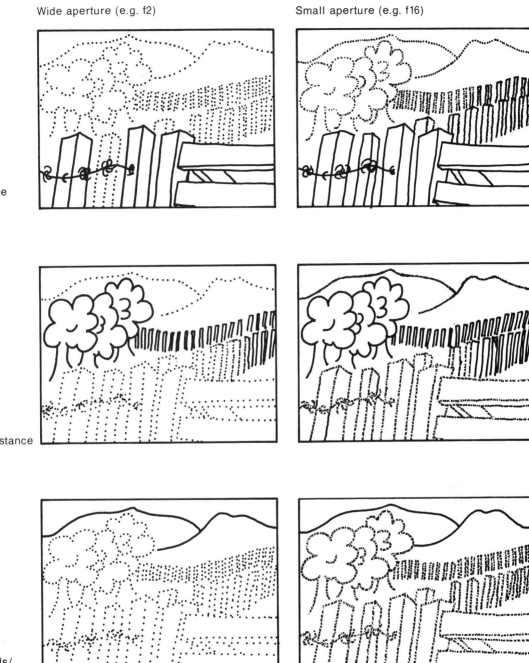

Focus on gate
foreground

Focus on
trees/mid-distance

Focus on hills/
background

27a Six depth of field examples. The wider the
aperture of the lens, the more the picture appears
to be in focus.

distance between it and the lens is the hyperfocal distance. If you now refocus on this point you will find that everything appears sharp from infinity right up to half the hyperfocal distance, and since this is often only a few feet, it is possible to get virtually the whole of the scene in focus at the same time.

a

b

28 Differential focus may be used to isolate a particular subject. (a) With the lens stopped down to f22 the plant is lost among all the detail of the background. (b) By opening up to f1.8 the depth of field is reduced and the background is thrown out of focus.

29 The large area of sharpness in this picture was obtained by focussing at the hyperfocal point –
in this case at 12 feet, using a Nikon camera with a 50mm lens set at f22.

CHOICE OF LENS

A selection of lenses of different focal lengths offers a useful means of manipulating the image. Although lenses vary only in the degree to which they bend light rays and, therefore, in the size of the image which they produce, the choice of lens can have a great influence on the qualities of the picture.

From any given point, lenses of any focal length (and indeed human eyes) will produce exactly similar images, except that some will be larger than others. Long-focus lenses will magnify the image so there will be room for only a small portion of it within the frame; this gives a narrow angle of view. Conversely, lenses of short focal length will include a great deal of the scene in the frame, producing a wide angle of view, but the size of any one part will, of course, be very small. Normal or standard lenses provide an angle of view corresponding to that of the human eye – the focal length of a standard lens will differ according to the format because, if the frame is larger more of the image will be included and the angle of view will be wider.

Towards the edges of the image there is an increasing amount of distortion, but with normal or long-focus lenses this part of the image is not included within the frame, and it only becomes apparent with wide-angle lenses. Fish-eye lenses include the greatest amount of distortion within the frame and this can sometimes be used to achieve a particular effect.

The magnifying of an image by a long-focus lens can cause perspective to appear compressed. This is simply a matter of the size of the image, the image itself is no different from that produced by a normal or wide-angle lens except that it is larger. In fact, if you took the negative produced by a standard lens and enlarged that section of it which corresponded to the picture framed by the long-focus lens, the result would be just the same. The effect is due to the size of objects appearing to change according to their distance from the viewer.

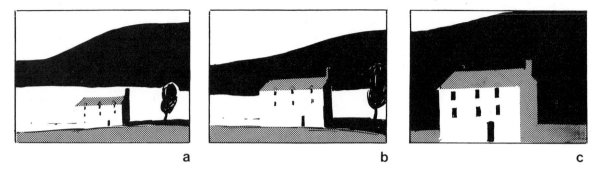

30 The same subject photographed with different lenses. (a) Wide-angle lens. (b) Normal lens (moving nearer to the subject). (c) Long-focus lens from the same position as (a).

Suppose, for example, a man is standing 20 feet in front of a bush which is about the same size as himself. If you then stand only 5 feet in front of the man, the image of him will be large and that of the bush comparatively small, because the bush is five times further away than he is. We are used to assessing the relative sizes of men and bushes, and we are able to make an accurate judgement of the distance between them. Now suppose that the man and the bush remain 20 feet apart but that you move back 300 yards – the bush is now no longer five times further away than the man. The man is 905 feet away and the bush 925 feet away; and the fact that the man is slightly nearer to you than the bush doesn't make that much difference to the comparative size of his image. Indeed, the images of both of them appear to be about the same size, they are both small and it is extremely difficult to judge how far they are apart. But you do not expect to be able to make accurate judgements at this distance. However, if you now take a photograph of them with a very long-focus lens (or if you look at them through binoculars) the size of the images increases. You expect images of this sort of size to vary somewhat if the objects are 20 feet apart, but the size of both images is practically the same, so the perspective appears to be wrong.

Now if this photograph is moved away from the viewer until the size of the images on it appears to be about the same as that of the image seen by the human eye, then things will seem to be normal. Viewing distance, since it affects the apparent size of the image, affects our appreciation of perspective.

A photograph taken with a standard or so-called normal lens will appear to be normal only if the size of enlargement and the viewing distance are kept within certain bounds. If it is enlarged to a photomural 6 feet long and 4 feet high, and viewed from a couple of feet away, then it will exhibit the same flattening of perspective associated with long-focus lenses.

The size of the image is determined by the distance between the camera and the subject, by the focal length of the lens, by the degree of enlargement of the negative or transparency and by the distance from which the photograph is viewed. If the image size is increased for any of these reasons, the depth of field will be reduced and our appreciation of perspective will be affected.

The focal length of the lens, therefore, should not be chosen without regard for the other factors. Suppose, for example, you wish to photograph a distant tree in front of an even more distant house. With a standard lens you could photograph the whole scene, and then simply enlarge the small area of negative upon which it appeared. This would naturally involve a loss of quality. Alternatively, you could get nearer to the tree, but this would alter the composition because the comparative sizes of the images of the tree and of the house would be different. By using a long-focus lens, however, the image of the tree and the house could be made to fill the frame so that the whole area of the negative could be printed. And the tree and the house would maintain their relative sizes.

To summarize the effect of various lenses: a standard lens under normal circumstances will produce an image roughly corresponding to that seen by the human eye. A wide-angle lens will include more of the subject, and there will be a greater depth of field. A long-focus lens will magnify a small part of the subject, there will be a shallow depth of field and the perspective will tend to be flattened.

a

b

31 The same subject taken from the same position with lenses of different focal lengths. (a) 28mm lens. (b) 55mm lens. (c) 200mm lens.

c

CAMERA MOVEMENTS

With monorail cameras the image may be manipulated to quite a large extent by altering the relative positions of the front and rear panels. Various adjustments will increase the depth of field, or alter the position or even the shape of the image. The main movements are swinging and shifting.

Shift

In this movement the front and back panels remain parallel to each other but the lens axis is shifted either vertically or horizontally. This allows objects which are outside the normal field of view to be included in the frame without having to tilt the camera, which would distort the shape of the image. By the same means, of course, unwanted objects may sometimes be excluded from the picture. Suppose for example, you wish to photograph an old barn, and you require a head-on shot of the façade. Unfortunately, if you stand directly in front of it, a tree slightly obscures the left-hand side. You then move to the right to miss out the tree but then the barn is no longer centred in the frame, and if you turn the camera to include the whole barn, the shape of the image changes – it is no longer square. However, if you keep the camera parallel to the barn but slide the lens panel to the left and the rear panel to the right, you can centre the image without distorting its shape. Similarly, you can include the tops of tall buildings by raising the lens panel.

Swing

If either panel is tilted backwards or forwards, or swivelled to the left or right, the shape of the image will be distorted and the focus will be altered. This is because the image is larger in some areas than in others, since some parts of it are nearer to the lens. So it is possible, by this means, to alter the shape of the image, to control perspective and greatly to increase the depth of field.

EXPOSURE

To ensure accurate results it is necessary to have fine control over the amount of light which is received by the emulsion. Exposure is determined by the intensity of the light and by its duration. The diaphragm regulates the aperture of the lens and thus the amount of light which passes through. It is calibrated in f. numbers which follow a conventional progression: f1, f1.4, f2, f2.8, f4, f5.6, f8, f11, f16, f22, f32, f45 and f64. Each successive

number allows half the amount of light through as the one before. And, since the f. number is related to focal length, the image transmitted by any lens set to a particular f. number will be of approximately the same brightness.

The duration of the exposure is determined by the shutter speed, and this is usually marked in seconds in a similar sort of progression to that of the f. numbers: 1, 1/2, 1/4, 1/8, 1/15, 1/30, 1/60, 1/125, 1/250, 1/500, 1/1000 and 1/2000. Thus each setting gives about half the exposure as the one before. This means that if you increase the aperture by one stop, you will double the amount of light passing through the lens, and so, to obtain the same exposure value, you will have to increase the shutter speed by one setting, thus halving the time during which the light falls on the emulsion. For example, if your exposure metre indicates a setting of 1/125 second at f2.8 but you wish to shoot at f2 to reduce the depth of field, you will have to adjust the shutter speed to 1/250 to keep the exposure constant.

The correct exposure can be determined either by a through-the-lens (TTL) metering system or by the use of a separate exposure meter. In any case, even with a fully automated system, it is possible to adjust the exposure in order to achieve exactly the right effect.

In most scenes there will be a wide range of tones, and, if you are using a separate meter you should take readings of both shadows and highlights, and use an average setting. If the tones are evenly distributed, most TTL systems will deal with it automatically, but if the tones are separated into large areas – a dark wood, for example, seen against a light sky – the reading is likely to be biased towards one or other of these extremes. In this case, the camera should be aimed at each area in turn and an average found. Alternatively, a reading can be taken from the important area only, so that the bias is under your control. Particular care should be taken with back-lit subjects, because the reading tends to be distorted by the light background.

Exposure may be used selectively in order to control the image. You may, for example, expose for the highlights and let the details in the shadows disappear into total blackness, or, conversely, you may expose to retain the details in the shadows and let those in the highlights burn out. You may also deliberately over- or under-expose a film in order to achieve a particular effect (you can increase contrast, for instance, by under-exposing and

increasing development time), but care should be taken with colour films, particularly transparency materials, since they do not have as much latitude as black and white.

FILTERS

Colour films are balanced for the particular colour temperature of the light source – the two main types being daylight and artificial light. However, the colour temperature of daylight varies a good deal, and while the human brain can compensate for these changes, film cannot, so it is sometimes necessary to make corrections by the use of filters.

In the case of black and white films, their response to various colours is different to that of the human eye. For the most part this is of no consequence, but occasionally correction will be required. The emulsion of black and white films tends to be oversensitive to blue, for example, and if you try to photograph white clouds against a blue sky you may well find that both sky and clouds register as an indistinguishable light tone. Con-

32 An orange filter increases the contrast between sky and clouds by darkening the blue of the sky. (a) Without filter. (b) With filter.

trast between them can be restored by using a red filter to darken the blue – a less pronounced effect can be achieved by the use of orange or yellow. A filter will lighten its own and similar colours, and darken those which are complementary.

Filters may be used not only to produce a more natural-looking result, but also to manipulate the image: to exaggerate, to distort, or to concentrate attention on a particular aspect of the subject. Since filters absorb a certain amount of the light passing through them, extra exposure is required to compensate. The amount of extra exposure will vary according to the strength of the particular filter, and this is indicated by the filter factor. A filter factor of 2X, for example, shows that the normal exposure must be doubled. With TTL metering, it is not necessary to make these adjustments, as readings are taken of the light which

actually passes through the lens. However, some meter cells are oversensitive to red, and if exposure is critical, it may be as well to take a reading without the filter and then make adjustments for the filter factor.

Filters for Colour Films

Light Pink or Skylight Reduces the bluish tinge which occurs in open shade or with distant landscapes. Can be used as a permanent lens protector.

Light Brown Eliminates the excessive blue which occurs in overcast or rainy weather. Or may be used simply to produce a 'warmer' result.

Dark Brown A correction filter to enable 'natural' results to be obtained when using Tungsten-type film in daylight.

Light Blue Eliminates the red/yellow cast which occurs in photographs taken in evening or early morning light. May be used simply to produce a 'cooler' result.

Dark Blue A correction filter to allow daylight film to be used with artificial light.

Filters for Black and White Films

Yellow Absorbs, to some extent, ultraviolet and blue light. Increases contrast between clouds and blue sky.

Orange Has a more pronounced effect than yellow, producing greater contrast between sky and clouds. Accentuates detail and texture in yellowish subjects such as autumn leaves or rocks. Adds detail to distant landscapes.

Red Creates the most dramatic contrast by rendering blue dark, and red and yellow light. Cuts through haze, bringing out details in distant scenes. Also used with infra-red film.

Green Lightens greens and darkens reds. Useful for accentuating detail in grass and foliage.

Filters for All Films

Ultra-Violet (UV) Eliminates ultra-violet light without affecting visible light. Cuts out haze. Gives clearer pictures. May be left on permanently as a lens protector.

Neutral Density (ND) Reduces the amount of light passing through the lens by subduing all colours equally. Used with fast film in bright light, where the minimum aperture and the fastest speed would still lead to over-exposure. Also enables a wider aperture to be used at any given speed, to achieve shallower depth of field. Available in a range of filter factors.

Polarizing Filter Eliminates reflections from non-metallic surfaces such as glass or water. Cuts out glare and helps rendering of form and colour.

Filters and Lens Accessories for Special Effects

Diffuser Gives a soft-focus effect. Some models may be adjusted to give various degrees of diffusion.

Centre Spot Diffuser A clear spot in the centre gives a normal, sharp image, while, towards the edges, the picture is diffused.

Centre Spot Colour Filters Coloured filters with a hole in the middle. With colour films, the central part of the image is rendered in its normal colours, but the surrounding area has a strong cast.

Half Colour Filters One half of the filter is clear and the other coloured. So that, for example, the sky could be made to appear violet while the ground retained its natural hues. Filters are also available in various combinations of two or three colours.

Variable Colour Filters These are made from a combination of polarizing and colour filters so that it is possible to vary the effect of the colours by rotating the filter frame.

Star Filters Produce dramatic, star-shaped flares from very bright highlights. Only bright points of light in the subject will work – the sun, for instance, or reflections of it from the surface of water. Several sorts are available, giving four, six or eight pointed stars, or giving various rainbow effects.

Great discretion should be exercised when using special effects. It is very easy to be seduced by the dramatic and the unusual, but unless a particular effect actually helps you to make your point, it will probably detract from the real force of your communication. Sometimes these effects can be useful, but unless they are handled with great skill they will appear as nothing but shallow tricks.

CONTROL OF THE IMAGE DURING PROCESSING AND PRINTING

The choice of film, printing paper and processing chemicals will affect the quality of the photographic image. Fine grain will produce a wide range of subtle tones and a good resolution of detail, and although acutance or sharpness is not entirely due to grain, fine grain will tend to produce sharper pictures than coarse grain. This high technical quality is neither good nor bad in itself. Once again, it all depends on what best helps you to interpret the landscape, and it might be that

what you need is a grainy, coarse image with a limited tonal range.

Slow films have very fine grain, give very sharp definition and tend to produce higher contrast than fast films. Conversely, fast films have coarse grain, give poorer definition and generally produce less contrasty results. The type of developer affects grain, and special fine grain developers are available (Acutance developers produce a sharp image without producing fine grain.) Over-exposure or prolonged development will increase graininess, as will enlargement.

So to produce a high-quality, fine-grain result you should use a slow, fine-grain emulsion, avoid over-exposure and prolonged development, use a fine-grain developer and restrict the degree of enlargement. The larger the negative, the less enlargement is required to produce a print of any given size. So large-format cameras tend to produce higher-quality results.

If you wish to produce grainy pictures, of course, you should use fast film with ordinary developer, and increase the degree of enlargement – this might mean shooting your photographs with a wider-angle lens and enlarging a small section of the negative. Negatives can also deliberately be under-exposed and then treated with a chemical intensifier. Grain is slightly more obvious with a condenser enlarger than with a diffusion enlarger, due to the sharper image.

The contrast of the image depends on the speed of the film, the length of development, the type of developer, the type of enlarger and the grade of

33 This photograph was taken in very dull, misty conditions on high moorland in winter. The feeling of desolation is enhanced by the graininess and the limited number of tones. It was shot on 400 ASA film and, in order to achieve maximum contrast between the patches of snow and the ground, it was printed on grade 5 paper with extended development time.

printing paper. Although any of these means may be used to control contrast, in practice other factors may well determine the film speed and the types of developer and enlarger. And, except in the case of sheet film, there will be several exposures to be developed at the same time, some of which may require much more contrast than others. The printing stage, however, offers a good opportunity to influence contrast. Not only can the grade of paper be selected, but the exposure and development can be manipulated. A more contrasty result is obtained if the exposure is reduced and the development time correspondingly increased.

Other controls available during printing are burning in and holding back (which we have already described), and cropping.

Cropping is the selection of only part of the negative for enlargement, and is an extremely important way of modifying the picture. There is a very strong tendency to compose a photograph through the viewfinder, but the proportions which this imposes upon you may not be the best for the particular image with which you are dealing. And, again, why should you be limited by the proportions of the printing paper which the manufacturers happen to produce? It may be that a long, narrow format is required for a particular subject, or perhaps a square, or even a circle.

Although you can assess the possibilities when you examine the contact prints, the ideal way of working is to plan the final format before you take the shot.

34 To achieve a composition of strong horizontals, this shot of mountains in Norway was taken with a wide-angle lens. Then just a portion of the 35mm negative was enlarged.

A chalkland field photographed at three different times.
a Early spring 1979. **b** Late spring 1979. Both shots taken
with a Pentax SP 1000 using SMC Takumar 1:2/55 lens.
c Late summer 1979. This shot was taken with the larger
format 6x7cm Pentax, using a wide-angle lens. *Gerald
Woods*

Landscape near Stonehenge, Wiltshire. Taken with a Pentax 6x7cm on an overcast day.

A view of the forest of Tholonet near Aix en Provence, where Paul Cezanne produced some of his finest landscape paintings. Taken with a Pentax SP 1000, using SMC 1:2/55 lens. *Gerald Woods*

6 Retouching, Print Finishing and Mounting

The final preparation of work for exhibition, or for the process camera if it is to be reproduced, is of great importance. It is not simply a question of making the picture as attractive as possible. The effectiveness of any piece of visual communication depends not only on its content and how the content is dealt with, but also on the way in which it is presented. Yet again, everything matters; everything which affects the viewer's perception of the picture will modify his response – it will either strengthen what you wish to say, or it will weaken it.

If, in spite of all the care which you have taken during its manufacture, your photograph contains imperfections, the ideal remedy is to start again, and to hope to avoid the problem the second time round. However, this solution is often impracticable. Apart from the fact that conditions of light and weather cannot be reproduced to order, there may well be many reasons why it is not possible to reshoot. In these circumstances it will be necessary to retouch either the negative or the print or, indeed, both. Even if you do not attempt the more sophisticated retouching techniques, you will almost certainly need to spot your prints from time to time. Retouching will enable you to remove blemishes and to correct certain errors. It also offers the opportunity to modify your pictures to some extent, and it is this facility which causes many a purist to regard it as being, in some curious way, morally wrong.

However, since no photograph is a literal translation of the truth, but simply someone's attempt to express it, there surely can be little objection to the photographer exercising any controls over his medium which are available to him. And retouching provides a very useful control. It can allow you to present information more clearly by suppressing misleading details; it can also, on the other hand, be used to make important detail more easily perceived.

Manual skill is required in almost all retouching operations, and this, of course, can only be acquired by practice. The whole job will be made much easier if you obtain a few good quality tools and keep them in good condition.

TREATING BLACK AND WHITE NEGATIVES

A negative which is very much too dark or too light, and which cannot possibly be reshot, can be treated with a reducer or an intensifier. This will not produce the same results as would have been achieved by correct exposure and development, but it sometimes enables an acceptable print to be obtained from a negative which would otherwise have had to be abandoned.

Reduction is usually carried out with a preparation of potassium ferricyanide and hypo. This is called Farmer's Reducer, and is easily obtained from photo stores. The negative is placed in the solution and then in water to stop the action. The process is repeated until the desired density is reached.

Intensification is usually achieved with a chromium or copper intensifier. Again, this may be obtained already made up. Obviously, only detail which is present in the first place can be intensified, and, for this reason, negatives which are suffering from under-development will respond better than those which have been under-exposed. Both reduction and intensification tend to increase contrast and graininess.

Apart from this over-all treatment, reducers and intensifiers may be applied locally to selected areas of a negative. After the negative has been rinsed in water, the solution is applied with a brush to the particular part of the image. If the chemical spreads onto a part for which it is not intended it is immediately mopped up with a piece of blotting paper or cotton wool. Even results can be obtained by using a weak solution, by keeping it moving and by constantly washing it off and repeating the

whole operation until the desired density is reached. If a very sharp outline is required, use an asphalt varnish or rubber solution to mask off the parts of the image which are not to be affected. The whole negative may be immersed in the reducer or intensifier, the coated areas being protected by the varnish.

The other procedures which may be employed with negatives involve finer work and are much more easily carried out with the larger formats. Apart from the obvious difficulties in working on a small scale, the smaller sizes usually undergo a proportionally greater enlargement which will reveal inaccurate work. Also, the emulsions of miniature negatives are thinner and less able to take heavy working.

So that you can see exactly what you are doing, the negative must of course be lit from behind during the following operations. A magnifying glass on a stand will also greatly assist the more delicate work.

If more than one of these treatments is necessary, they should be carried out in the order in which we have given them, so that one procedure will not interfere with the results of another.

Dying

Some negatives are well exposed in the highlights, but are relatively thin in the shadow areas. The usual way of dealing with this problem would be to hold back the thinner areas with a dodger during printing, and to use a softer grade of paper. However, it is possible to correct this fault on the negative by staining the appropriate parts of the emulsion with dye. This has the effect of holding back the treated parts, and allowing the detail to emerge. The advantages of this method are that various parts of the negative can be held back to different degrees; the areas can be accurately defined, and the negative, once treated, can be printed without further trouble as many times as is required.

The effect of this treatment is to reduce the contrast between the highlights and the shadows. It is used when sufficient detail is present but is lost because the exposure necessary to print the highlights results in the shadows being over-exposed. Local intensification, on the other hand, is used in cases where detail is insufficient.

The dye should be applied to the appropriate areas in a series of dilute washes, until the desired density is built up. A sable brush should be used which is large enough to hold sufficient dye to cover the whole area, but which retains a good point. Do not overload the brush, and apply the dye sparingly. To ensure that an even result is obtained, the whole surface to be treated should be covered as quickly as possible. No part should be overworked. If too much density is built up, it is usually possible to rinse off the dye and to start again.

Spotting

Flaws in a negative due to particles of dust which have adhered to the film causing unexposed pinholes, or due to the emulsion being scratched, can be treated by spotting. It is often easier, particularly if the damage is extensive, to deal with it at this stage, since work on black spots on a print are more difficult to conceal.

A very fine sable brush is required (size oo or ooo), which will hold a good point. The brush should be dipped in water, given one shake so that it comes to a point, and then any stray hairs should be burned off in a match flame.

Gouache, or other opaque spotting pigment may be used. It is mixed to the required consistency, using a drop of gum to make it adhere. Saliva will also help to make it stick. It should be applied with the tip of the brush nearly dry. A series of tiny dots are used to fill in the hole until the tone matches the surrounding area. Small pinholes can be treated with a single dot in the centre.

It is better to make the repair too dark rather than too light since it is easier to remedy lighter spots on the print. On miniature negatives the degree of enlargement may make your dots unacceptably large, in some instances this problem can be avoided by using dye. Dye is transparent and can be used as an over-all wash. Again, a nearly dry brush is used and the tone built up in a succession of dilute washes. Particular care should be taken with pinholes to avoid filling them with a wet blob which will dry leaving a noticeable ring. This method is not possible where the emulsion is missing altogether. In all cases where the technical difficulties are too great, or where you feel you have insufficient manual skill, it is better to fill in the affected area with solid pigment and to deal with the problem on the print. The increased scale will make the job much easier.

Knifing

Black spots and lines and unwanted detail may be removed and larger areas lightened by the use of a

35 Retouching equipment: box of pigment in various warm and cool tones of grey, clutch-pencil, sable brush and knife.

knife. This requires quite a good deal of skill, and should not be attempted without practice on old negatives.

The knife must have a very sharp, scalpel-like blade. It should not, however, have too thin a point or it will be liable to vibrate.

The emulsion is gradually removed with a series of very light, even strokes. The aim should be to start the stroke before contact is made, and then merely to brush the surface. The area to be treated is covered with a succession of parallel strokes, then the negative is turned and strokes applied in another direction. Even when a spot or line is to be removed altogether, it should never be crudely scratched out. Extreme delicacy and patience is required at all times.

Pencil Retouching

In the old days, portrait photographers used to retouch their negatives in order to rejuvenate the image of their clients. Wrinkles, lines and blemishes were fairly easily removed by the use of the pencil. In fact, pencil retouching offers a very good means of building up the density of small light areas, and of suppressing or removing details.

So that the negative will accept the pencil marks, it is coated with retouching medium to give it 'tooth.'

A useful range of pencils would be 4H, 2H, HB and 2B. Clutch pencils with separate leads are ideal. If a dark tone is required, then a soft lead such as 2B should be used. Lighter, more delicate retouching is carried out with the harder grades, such as 4H or 2H. One of the advantages of pencil retouching is that it is relatively simple to match the tone of the surrounding area with the appropriate grade of lead.

The negative will accept only a certain amount of graphite, so it is not possible to build up density with successive applications.

The pencils must have very long, very fine points, which should be frequently re-sharpened. A light touch is required, and the pencil should be gripped well back from the point.

A continuous series of tiny loops is drawn evenly over the whole area to be treated. The smaller the loops and the finer the pencil point, the better. The same series of tiny loops is used, even when thin

lines are being filled. Very little pressure should be used; indeed, the point should be so sharp that anything but the lightest stroke would break it.

If mistakes are made it is possible to wash off the graphite and the retouching medium with white spirit, and to start all over again.

RETOUCHING BLACK AND WHITE PRINTS

Most of the negative retouching techniques which we have described can be used equally well on prints which are intended for mechanical reproduction. In fact, the degree of manual skill required is less in view of the increased scale. These operations often alter the surface texture or give rise to discolouration. This, of course, is of no consequence with negatives, or with prints prepared for the process camera, which are simply intermediate stages. The problems arise with prints which are required for exhibiting, when such work may be easily noticed. In this case, the amount of retouching which can be done depends on the surface of the print. Matt papers will allow quite a lot of work to be done, while on glossy, and especially on resin-coated papers, retouching must be limited to careful spotting.

Reducing

Over-all reduction and intensification will not be necessary, since errors in exposure or development are easily remedied by reprinting.

However, local reduction may be required to lighten shadow areas which have become too dense. Farmer's Reducer tends to stain the silver image, and it may be necessary to use another reducer such as potassium permangate for this purpose. On the other hand, Farmer's Reducer is ideal for removing stains caused by the use of exhausted fix or by excessive development. Parts of the image can be removed completely, leaving a pure white area, either with this reducer or, better still, by an iodine bleacher.

Matt Papers

Matt-surfaced papers will take pencil, pigment and dye, and can be knifed without the work showing. The size of spots caused by particles of dust or other matter on the negative will, of course, be increased by the degree of enlargement. Prints from 35mm negatives are particularly liable to give trouble on this account, and great care should be taken during printing to keep everything as clean as possible.

The spotting of prints is carried out in the same way as with negatives. Special water-colour pigments or dyes are available, and are applied in a series of tiny dots. The greys of monochrome prints vary considerably from one paper to another, some being very much cooler than others. It is therefore necessary to match not only the tone, but also the colour of the surrounding area. Pigments should be mixed together and tested on a piece of white paper until the appropriate colour is obtained. The tone will depend on the size and number of dots used, as well as the darkness of the pigment. For this reason you may find that you have to mix your colours somewhat darker than the area you are matching.

As with negatives, the pigment is applied with a finely pointed oo or ooo sable brush, which should be just moist enough to do the job.

Matt papers will accept pencil work, and in fact, spotting of the lighter areas is often most easily accomplished by this means.

Black spots are easily removed by careful scraping with a sharp knife.

Glossy and Resin-Coated Papers

These papers are hard to work on. Apart from the difficulty of getting the surface to accept the dye or pigment, it is almost always possible to detect the work when the print is viewed in a certain light.

A drop of wetting agent, such as Kodak photo-flo, added to the colour, will help it to stick. Alternatively, saliva or a small amount of gum arabic may be tried. In the case of resin-coated papers, a drop of acetic acid should also be added to the mixture.

As it is not practicable to knife the glossy surface, black spots must be covered by an opaque white water colour, such as process white before spotting is carried out in the usual way. Sometimes a sort of reverse spotting of black marks is possible, using tiny dots of opaque white.

RETOUCHING COLOUR NEGATIVES AND PRINTS

The retouching of colour negatives is extremely difficult and is usually limited to opaquing out pinholes so that they can be spotted on the final print.

Correction of transparencies is hardly worthwhile, but if it is to be attempted at all, it must be done with transparent dye, since opaque pigment would appear black in transmitted light.

Colour prints may be spotted with dye or water-colour pigment, and various specially formulated

preparations are available. In the case of white spots the dye should be stippled in with the very fine point of an almost dry brush. Do not try to fill in the spot with the first application. If you build it up gradually you will be able to change the colour of your dots, and match the spot to the surrounding area by the time the correct density has been reached.

If the spot is the result of damage to one of the colour layers, it will appear as a mark of an incorrect hue. This can be corrected by stippling with the pure colour of the missing layer.

The over-all colour of certain areas in a colour print can be changed by applying a series of dilute washes of dye. This operation, however, requires a great deal of skill and judgement and should not be undertaken lightly.

MOUNTING

A collection of prints may be displayed in a special folio containing transparent wallets which can be turned like the pages of a book. A print which is intended for exhibition, however, will be shown to its best advantage if it is first mounted on board. The easiest and most efficient way of doing this is to use a dry-mounting press. The board and the print are joined together by a thin sheet of tissue which melts in the press. To avoid warping, all moisture must be removed from the board by putting it into the hot press for 10 seconds or so and then releasing it. This procedure should be repeated a few times. A sheet of dry-mounting tissue is then attached to the back of the print with a dab from a hot tacking iron. Then the print and the tissue are trimmed to the required size. (A print trimmer or a guillotine is best to ensure that the edges are square.) Print and tissue are now both exactly the same size and are held together at one small point. The print is then placed on the board and tacked into position by a dab with the iron on each corner of the tissue. (The board must be larger than the print, even if you intend eventually to trim them both flush. If desired, several prints may be mounted on one board.) The surface of the print should be protected by a clean piece of cartridge paper. The whole sandwich is then put into the hot dry-mounting press which melts the tissue and fixes the print to the board.

The temperature of the press must be regulated according to the manufacturer's instructions, and care must be taken not to leave the print in too long. It is often better to give several short nips in the press than one long one. Extreme care should be taken with colour prints as they are particularly susceptible to damage.

The print should now be completely attached to the board and should be perfectly smooth and flat.

7 Ways of Seeing

THE PROBLEMS OF PERCEPTION

For most of the time we are in too much of a hurry to take in detail. Travelling at high speed in a car or train, we might glance absent-mindedly at a landscape view, and yet our minds are so preoccupied with everyday problems, that we tend to shut out a whole world which beckons our perception. It sometimes happens, however, that our attention is arrested by a small incident or detail – a white bird, appearing as a tiny speck in a vast expanse of sky, catches the light, and for a moment it seems there is nothing in the sky save that small bird whose form we can barely identify.

Paul Nash spoke of the 'peculiar power of the camera to discover formal beauty.' The camera can be used as a tool for extending our powers of perception, and to penetrate a world that is hidden from casual observation – the world which Blake tells us is to be found in a grain of sand. In his treatise on painting, Leonardo Da Vinci expressed the need to look more closely at hidden forms – 'look at certain walls stained with damp, or at stones of uneven colour,' there he says we will find 'divine landscapes, adorned with mountains, ruins, rocks, woods, great plains, hills and valleys in great variety.' This is not to suggest that the reader should now start to examine damp walls or grains of sand! The point is that the landscape photographer does need to develop his powers of perception if he is to produce anything worthwhile.

We see what we expect to see, and what we expect to see is often conditioned by what we have read. In the Western world, culture is to a large extent founded on literary concepts. The necessity of acquiring the basic tools of communication, speaking and writing, is the primary cause of our initial detachment from equivalent visual experience. From an early age children are taught the basic skills of language structure, writing and reading, but their visual education is often sadly neglec-

ted, and in many schools art instruction is still regarded as a recreational activity. A picture painted by a child may be full of clichés picked up from simple written descriptions – the blue sky, the brown tree, the red roof, the pink face. He has absorbed a whole range of preconceptions that are almost never true. This is not merely a problem of childhood; it persists into adult life. Words continue to conceal rather than reveal. There are many writers and poets who are able to evoke something of the atmosphere of a scene with economy of expression, but for the most part words are such poor, blunt instruments that it requires a great many of them, qualifying and requalifying one another, even to begin to describe the simplest landscape with any useful degree of accuracy. So most of us sometimes crudely and unthinkingly tend to categorize our visual experiences by the use of convenient adjectives – a spiky tree, a green field. Sir George Beaumont once asked Constable, 'Do you not find it very difficult to determine where to place your brown tree?' 'Not in the least' replied Constable, 'for I never put such a thing into a picture.' If one considers for a moment the phrase 'green field', 'green' is the adjective used to describe a momentary sensation of a patch of colour. Assuming that the observer is scrutinizing the patch of colour with care, it may in fact be seen that because of the quality of light falling on that area, the field is not green, but a variety of colours fused together with a predominant hue. However, having stored this sensation in the mind, the need for accuracy in reporting this fact does not arise. Thus the colour of the field is described as one would expect it to look under 'normal' conditions, and, by common consent, we expect the field to be green.

The mind is a repository of complex personal sensations, yet we tend to convert our visual experience into terms which are more generally acceptable. Descriptive comments are usually

hampered by the limited range of our vocabulary and the need to communicate with economy of expression. The problem of perception is that we find difficulty in giving a satisfactory account of our sensory experience in a form which is both acceptable and accurate.

By recording or responding to our sensations in purely visual terms, through the media of drawing, painting or photography, we come nearer to providing a more suitable framework for our visual experience. Yet both painter and writer (and the photographer), can be equally guilty of giving a careless report of their sensory experience. By observing, the spectator is trying to find out about an object. But just how much he uncovers is dependent on the amount of effort he puts into scrutinizing that object. Mistakes arise from careless or hasty observation, and the degree to which a work of art bears the imprint of perception is only too evident in the drawing, painting or photograph made from direct observation. If we are sometimes mistaken in our observation of objects, we are never mistaken in our sensations. For example, given that we are observing in an investigatory sense, we may not be sure if the tree seen on a hillside is an ash or an elm, or if in fact it is a tree at all. But we *are* sure that there exists a near-black skeletal shape rising from the ground. The photograph of the tree (see photograph 36) shows that its growth has a strong directional emphasis to the right. On closer scrutiny we are able to receive information from purely visual signs – the tree has been formed and shaped in that direction by the force of strong winds.

For most of the time we are looking rather than seeing. One thinks of the series of photographs which Paul Nash called his 'unseen landscapes' – unseen because they are not perceived. It often happens that objects which are just in front of us are the most difficult to perceive. By photographing drystone walls, dead trees, and so on, Paul Nash was attempting to increase his understanding of such things, which often come within our field of vision, but fail to register as significant forms in their own right.

Landscape is indeterminate, allowing the eye to select freely and to group and compose various elements. Each of us has the task of trying to rediscover the landscape we inhabit through our own stream of consciousness. To do this a series of senses are necessary. We need a sense of scale and proportion, rhythm and movement (nature is never still), a sense of the spatial immensity of landscape, of advancing and receding forms, of structure and of the organic nature of growth.

The secrets of landscape are revealed to us in different ways – if two people were to stand side by side on the brow of a hill and look down to a valley below, the measure of land occupying the visual space of each person would be roughly the same. Yet because the duality of perception cannot be unified, each would realize a different sensory experience. Whereas one might be intent on observing a particular object in the valley, the other might sense only the general atmospheric qualities of light.

The painter Paul Cezanne in an article published in the magazine *L'Occident* (1904), said – 'Painting from nature is not copying the object, it is realizing one's sensations.' He went on to say – 'There are two things in the painter, the eye and the mind; each of them should aid the other. It is necessary to work at their mutual development, in the eye by looking at nature, in the mind by the logic of organized sensations which provides the means of expression.'

One analogy we can make with the camera is that, just as the photographer is continually having to refer to his light-meter to get a correct measurement of the light value for exposing his film, so the eye has to adjust to the conditions of light which are changing continuously. The visual pattern which reaches the brain is never static, it is in continuous movement as the qualities of light in landscape are constantly shifting.

COMPOSITION

The photographer approaching a landscape subject for the first time will no doubt be overawed by the immensity of the view he is confronted with. Like a hunter armed with a shotgun, there is a tendency for the beginner to start 'shooting' film indiscriminately. While this approach might produce a few happy accidents, there is inevitably a feeling of disappointment when the prints don't reveal the kind of images one had anticipated. Landscape is perhaps the most difficult subject to deal with in photographic terms – 'the supreme test of the photographer,' according to Ansel Adams. At the same time, for those who are patient enough to pursue the medium to this end, it can be most rewarding and more satisfying than any other aspect of photography.

Landscape photography demands more concentrated effort, and a close affinity with the subject. Some of the most successful landscape

photographers are people who really *care* about the land and have a genuine love of nature, which leads them to study its moods and changes. The best landscape photographs go beyond the mere recording of physical facts and the picturesque; they bear the imprint of an emotional response to the presence of the place. Cartier-Bresson once said that the thinking should be done beforehand and afterwards – never at the time when one is actually taking the photograph. Minor White hints at the same idea when he describes his landscape photographs as 'inner landscapes,' and, like Cartier-Bresson, suggests that the state of mind of the photographer is usually blank at the moment the exposure is made.

There are some landscape photographers who are in the habit of going out *without* a camera, to look for the right viewpoint, to examine the quality of light falling on the scene at different times of day, under different climatic conditions, and to take pictures mentally, before going out again with a camera. The image quite often exists in the photographer's mind before the actual moment when the film is exposed.

The indeterminate nature of landscape poses a particular problem for the photographer – while the human eye can scan a wide view of the land, the camera can only register a comparatively small area within a fixed rectangular or square format (even with the additional aid of a wide-angle lens). All photographs mirror small fragments of reality, and the ability to integrate the various elements of a landscape within the constraints of the viewfinder frame is therefore critical. Experienced photographers are able to compose a scene intuitively – some admit to having had some previous visual training, perhaps through drawing or painting. There are others who prefer to compose the

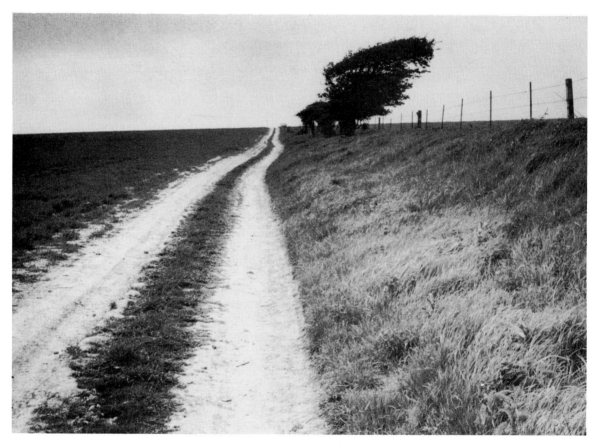

36 Tree-Firle Beacon, Sussex. The shape has been influenced by strong winds from the English Channel.

scene by masking out fragments of the negative during the printing stage; but for the inexperienced this can lead to unsatisfactory cropping of the image, unless it is done with great care, and with an awareness of all the compositional factors.

The landscape photographer, in common with the painter and musician, must have some basic grounding in the rules of composition, although that will not in itself produce photographs of excellence.

Essentially composition is concerned with creating order: arranging and placing the various disparate components of landscape in such a way that they 'jell' together visually. Composition is also about spatial relationships; the space between objects in the foreground, middle-distance and far distance. We must also think of space in terms of linear perspective, that is to say, the way in which objects appear to get smaller as they recede into the distance, and the way that lines appear to converge on the horizon. In composing a scene we must also be aware of the way in which patterns of light and shade can link the elements of landscape together. Photographic film does not register precisely the range of light and dark tones which can be taken in by the human retina transmitting thousands of sensory signals to the brain. It is possible, however, to exercise a considerable degree of control over the modulation of light and dark areas in the print, which in itself is a useful compositional device.

The shape, texture, pattern and tone of objects in a landscape must be considered when 'arranging' a fragment of landscape in the camera viewfinder. Swift described composition as 'a mass formed by mingling different ingredients.' The landscape painter can simply leave out any ingredients of the landscape which might in some way impair his composition. The photographer on the other hand has to contend with all the ingredients as they appear on his ground-glass screen. Sometimes when we are concentrating too much on a particular object which appears in the viewfinder, we are apt to overlook details such as the branches of a tree creeping into one corner, or telegraph wires which appear on the final print like scratches from the negative. Although it may not be possible to eliminate unwanted detail entirely, it is possible to make some intrusive objects appear less conspicuous, by exaggerating the darker tones and shadows, and by adjusting the focus and depth of field. One should try to make a single comment in each photograph – conflicting points of interest can destroy the visual unity of the composition.

The exquisite visual judgement that is evident in the work of photographers such as Edward Weston, Paul Strand and Ansel Adams, is the result of training the eye to go beyond the habit of seeing things in general terms, and to present the subject matter in such a way that it provides a kind of visual shock. Although one can learn a great deal from studying such 'cool' notions of composition, one should, however, avoid leaning too much on other people's ideas, and concentrate more on developing one's own sense of visual judgement. When working in any location, one should try to allow the scene to leave an impression on one's own consciousness, and to concentrate on the essential elements of the composition, rather than trivial detail. Far too many photographers adopt a fixed formula for composing photographs which is generally derived from the mish-mash of visual clichés extracted from photographic magazines.

Landscape is never still; it is vibrant, and it is made up of a great many planes, one behind the other, gradating in tone as they recede towards the horizon. A good landscape photograph can only provide a mere summary of what the photographer experiences visually; he projects himself into everything he is looking at. He then extracts from that scene what he believes to be most relevant in terms of form and structure, light and shadow, and is hopeful that by using the correct exposure, the film in his camera will register an image which will equate with what he has seen. We should not expect the photographer to make a factual record of all the physical features of a landscape; it should be enough that he hints at what is there, so that we in turn are stimulated to find out more about the place, and to search our own storehouse of knowledge and imagination to supplant any missing detail.

Composition should not be taught or applied too dogmatically; if we adhere too strictly to all the various rules and formulae, the resulting photographs will appear too contrived and self-conscious. At the end of the day we must rely on our intuitive sense of judgement, tempered by an awareness of visual relationships. Cartier-Bresson has expressed the view that composition must be one of our constant preoccupations, right up to the moment when we are ready to take a photograph, but from that point onwards our feelings should take over. A basic understanding of compositional values provides a kind of underlying invisible scaffolding for our ideas, rather than being an end

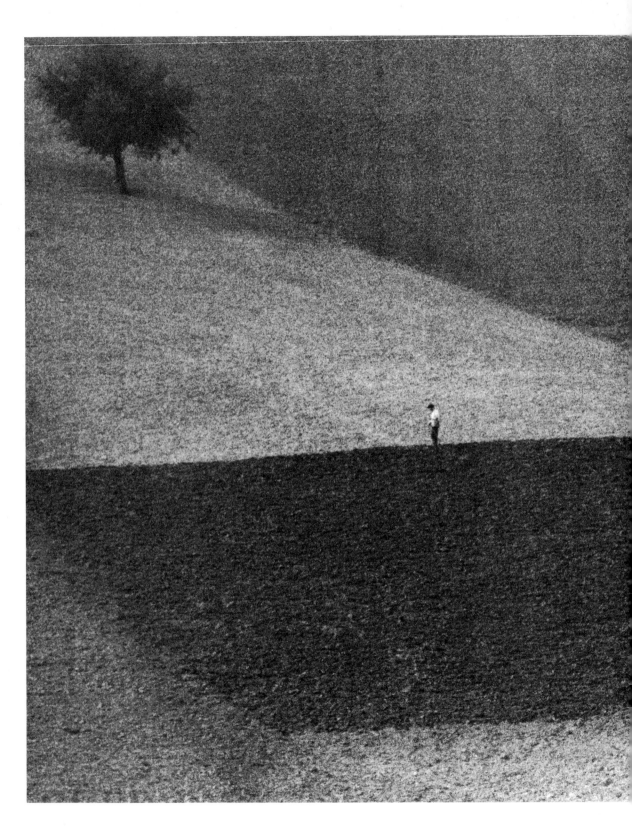

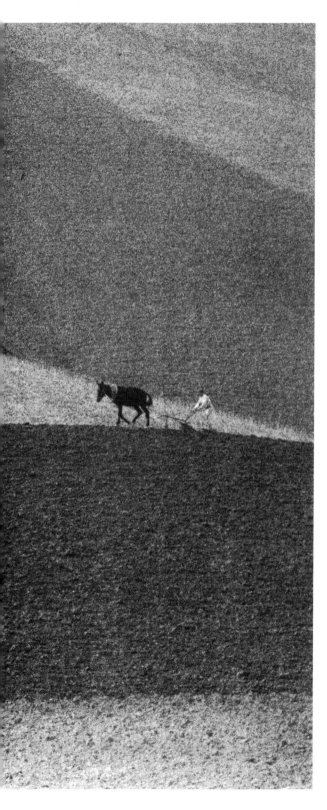

in itself. The hallmark of a well-composed photograph should be that we are not aware of the fact that the photographer has predetermined the composition.

Every photograph which one takes will in some way reveal certain aspects of one's personality – the images one selects and the way one composes a scene will expose a predilection for a particular kind of landscape and composition. This can also be extended to the processing and printing of the image; whereas one photographer might render a scene in terms of dramatic tonal contrasts, another might feel that more subtle gradations of tone are necessary to convey what he felt about a particular scene.

Edward Weston and other West Coast photographers were able to seek out locations which they knew would yield all the ingredients necessary for their own preconceived compositional formulae. Edward Weston's son has described how he used to drive his father around various locations looking for Weston-type landscapes!

When thinking about composition in photographic terms, one should be aware of the fact that the three-dimensional objects are represented by light and dark shapes disposed at different levels. This apparent abstraction of form in landscape photography is caused partly by the fact that the volume of objects such as hills, trees and buildings, are in appearance flattened by the diffusion of light. In composing a scene, therefore, one might consider whether the volume or solidity of significant forms should be emphasized, or whether the two-dimensional pattern of interlocking shapes is more critical. Then, having made a decision, one must photograph the scene under conditions of light most suited to one's purpose. This abstract concept of landscape photography is further heightened by the use of long-focus lenses, which tend to truncate and compress the distance between separate planes in such a way that the image loses all sense of depth.

Finally, a short time spent in any library looking at reproductions of landscape compositions by painters and early photographers, in order to see how they dealt with particular problems, can be

37 A scene from Tuscany, by Gianni Berengo Gardin. A classic example of pictorial composition which reveals the photographer's exquisite sense of visual judgement.

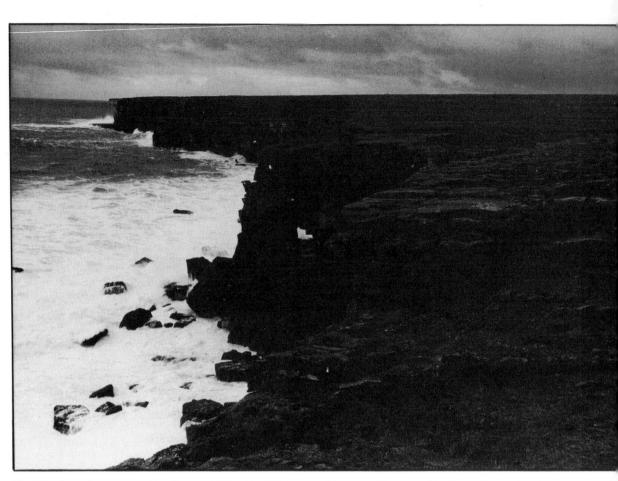

38 The Aran Islands, by Guy Ryecart. The somber tones of the coastline provide dramatic contrast ⎯ to the Atlantic spray.

quite rewarding. The paintings of Nicholas Poussin and Claude Lorrain influenced the composition of early landscape photography. Conversely one might also look at the work of the French Impressionist painters, whose work was undoubtedly influenced by the incongruous nature of the snapshot photograph. The classical landscape painters used a number of visual devices which lead the eye of the viewer towards the focal point of the composition – perhaps a path or river in the foreground, meandering towards a group of figures in the middle-distance, or to a distant building bathed in sunlight. Trees and buildings were carefully balanced to compensate for the lack of vertical structures in landscape. In contrast to the classical painters, the casual composition of the Impressionist painters is perhaps more akin to the way we see things today – photography has indeed conditioned the way we see things.

Contrast

Looking at the foliage of a tree overlapping the gaunt frame of a farm building, one is seeing contrasting soft and hard outline shapes – an obvious example perhaps, yet nature is so full of contrasting elements that we sometimes have difficulty identifying even the most obvious relationships. There are contrasts between man-made artefacts – roads, walls, bridges etc., and the natural growth which surrounds them. There are also more subtle contrasts between landscape elements – the stillness of a pool, the wave-like rhythm of ripening grain crops, a rugged escarpment of rock, a wall following the contours of farmland, and so on. Essentially one is concerned with contrasts in scale, vertical and horizontal, solid and translucent, hard and soft, light and shadow. One of the reasons perhaps why many landscape photographers have preferred coastal

locations is that they are fascinated by the contrasting nature of a rugged coastline against the advancing waves, the dynamic against the static, the opaque against the translucent.

For the landscape photographer, it is contrasts in tone which are the most critical – the way in which dark shapes can define lighter shapes and vice versa. The most conspicuous contrast in tone is between the land mass and the sky. One of the more common errors in landscape photography is that we tend to think of the sky as a featureless white shape – one is often so intent on photographing objects on the ground, that no attempt is made to register the tones of the sky. Whereas with the aid of a yellow or red filter many finely gradated tones in the sky can be brought out and contrasted with the darker shapes of the land mass, thus producing a more satisfactory tonal balance. A current trend amongst students is that the edge of the sky is determined by a finely drawn black line – this is often insensitive and bears no relationship to the tonal balance of the print as a whole.

Balance and Proportion

There is an obvious temptation for the beginner to try to arrange everything in perfect symmetry within the viewfinder of the camera. Unless there is some specific reason for doing so (to emphasize the geometric pattern of a formal garden for example), one should generally avoid an equable balance of all the various elements of the composition. In landscape, fields, trees, hills, walls and buildings are all poised on different levels, and are at varying distances in perspective towards the horizon. One is therefore concerned with trying to create a satisfactory relationship between elements which are disposed asymmetrically.

Perhaps the best known formula for producing a composition which is aesthetically pleasing is the division of a rectangle known as the Golden Section, or Medial Section, as it is sometimes called. The easiest method of finding the medial division in any given rectangle is to take a sheet of paper of the size one is working to, and first fold it in half three times in succession (do this for both the length and breadth of the sheet of paper). The folds will divide the paper into eight equal parts, from which a 3:5 ratio can be determined. (Alternative ratios might be 2:3/5:8/8:13.) This device works best in compositions where there are few elements; usually a significant vertical element such as a single tree in a field, or some man-made structure. We sometimes unconsciously tend

39 The Golden Section; ABCD = a square.

anyway to place the most significant element in that part of the picture plane which corresponds to the ratio of the medial section. This is because, guided by one's intuition, it seems right to punctuate the wide expanses of a landscape view with a carefully placed vertical form which will arrest one's attention.

The rectangular viewfinder of an SLR camera, or the larger format of a view camera, offers the choice of a picture shape – landscape or vertical. Nine times out of ten we tend to choose the horizontal format because this relates most to landscape subjects. There are instances, however, when the vertical format might be more appropriate. When, for example, one is photographing natural forms at fairly close range, the vertical format might encompass the growth of plants and trees more satisfactorily than would the landscape format.

When one talks about balance in a landscape photograph, one of the most important aspects to be considered is tonal balance – the way in which light and dark tones are disposed within the overall composition is critical. The balance of tonal qualities can greatly enhance the feeling of depth and volume, and can provide a link between objects in the foreground and in the far distance. The tonal definition can of course be extended by exposure control and by filtration at the time of taking the photograph, or during the printing stage by burning in and holding back tones. The most important element in a composition might occupy only a very small proportion of the total print area. One useful compositional device is the way in which objects in the foreground, which are in deep shadow, can be used as a frame or separator

40 Chalkland landscape. The eye tends to follow the diagonal line from the bottom right-hand corner, over the fold in the land, to the horizon. A single vertical structure – a telegraph pole, though placed intuitively in the viewfinder, correlates approximately to the Golden Section.

to lead the eye directly towards some tiny object in the far distance.

The pictorial theme, or the particular characteristics of a landscape view, can sometimes be affected by the position of the horizon in relation to other elements of the composition. There are of course no fixed rules; it depends what one wants to say about a particular place. In low-lying areas such as East Anglia in England, or the lowlands of Holland, the sky predominates, and the horizon is best when placed fairly low in the frame. Looking at the landscape paintings by Rembrandt, Ruisdael, or Constable for example, it is noticeable that the sky usually occupies about two thirds of the picture surface. The low horizon line expresses a feeling of expansiveness and great distance – in placing the horizon line too highly in the composition, one might easily convey the wrong impression of a lowland landscape by cancelling out the essential characteristics of a wide expanse of low-lying plain.

At times when it is necessary to place the horizon line fairly high in the composition, one lends greater emphasis to the weight and tonal balance – this is particularly useful when there are strong forms in the middle-distance. It is sometimes necessary to omit the horizon line, and indeed the sky, altogether – in doing so our intention might be to concentrate entirely on the detail of interlocking shapes which create a two-dimensional pattern. Where there are jagged shapes placed on the horizon – perhaps a mountain range, or a plantation of fir trees – there exists a sense of drama and anticipation which can be increased to some extent by allowing a much greater proportion of the land mass to encroach on the space at the top of the composition normally reserved for the sky.

Space, Depth and Structure

The cohesive qualities of a well-composed photograph are very dependent on spatial relationships. When we are looking at a photographic print, we tend to scan the image from left to right – the eye

follows a visual path through the composition, linking together the brighter tones. Mindful of the fact that photography is a two-dimensional medium, it is sometimes necessary to heighten the

41 Hopfields in Kent. The poles dispersed at regular intervals in the field define space, and emphasize the sense of perspective.

illusion of depth in the composition, by emphasizing the way in which forms appear to diminish in size as they recede into the distance, and the way that lines appear to converge on the horizon – or what is sometimes called the 'vanishing point.' Without this sense of perspective, landscape photographs can often appear dull and uninteresting. We can of course make use of the different focal-length lenses, but it is the choice of viewpoint which matters most when depth and perspective are crucial to the success of the composition. The use of a telephoto or long-focus lens can compress forms in such a way that the sense of perspective is lost. Whereas a wide-angle lens with greater depth of field will extend the impression of distance. When one focusses on the distance, rather than on the foreground, this also heightens the illusion of depth and perspective – the eye tends not to rest on objects when they are out of focus, it moves instead towards areas of sharper definition. Some of the more obvious visual devices in composition should be resisted – the leafy bough of a tree creeping in at one side of the frame, a single ear of corn in the foreground and so on.

The intrusion of conspicuous elements should be avoided unless they are there to make a specific point, otherwise they serve no other purpose than to distract from the main theme of the composition.

The sense of space in landscape photography is usually represented by the way in which tones and colours diminish in intensity as they recede towards the distance. The spatial qualities of the photograph are also dependent on the depth of field – if for example, the aperture is wide open, and one is focussing on an object in the foreground, the sense of depth would be confined to a very small area in the foreground. If, however, the aperture of the lens is stopped down, and the focus is on the middle-distance, the spatial qualities are expanded considerably.

The structural elements of a landscape composition are not always readily identified. This is partly due to the fact that the predominantly softer and irregular shapes in nature tend to merge together and conceal underlying forms. When we look at the heavily laden boughs of a tree in the height of summer, we tend to disregard the fact that there is an intricate skeletal structure support-

a

ing the soft external appearance of the tree. Conversely in winter months when that same tree has shed its foliage, we are acutely aware of the structural shape of the tree. Everything in nature has a basic structure – sometimes it is hidden permanently, partially concealed, or revealed at different times and in different seasons of the year.

When we refer to structure in landscape photography, we usually mean those components (seen and unseen), which hold together the imponderable mass of organic matter that makes up a landscape view. The geology of any region will obviously influence the surface appearance of the land mass – the underlying structure of a rock base will provide the main visual characteristics of each region. In a chalkland landscape, for example, the top soil is usually a very thin layer resting on absorbent soft compounded chalk. In these areas the landscape takes on the appearance of skin

tautly stretched over a soft, bone-like structure. Man-made structures situated at varying levels are more conspicuous, yet they too provide a visual link between one object and another, and between different planes as they recede into distance.

42 Two views of the same field taken in spring and summer. (a) In this photograph the structure of the walls dominates the composition. (b) The texture of the ripening crop in the foreground distracts our attention; the walls are no longer a dominant feature of the composition.

b

a

Man-made structures can also help us to define space and to increase our awareness of the relationship between natural forms and prefabricated forms. The series of photographs (43a–c) of a simple cantilever bridge offers an interesting example of the range of compositional possibilities. In the first photograph, the structures are evenly balanced, like bags of copper coins on a scale. Notice how the dominant triangular structure of the bridge from this viewpoint relates to the seated figure in the foreground. Wires and chains leading from the main structure also contribute to a feeling of tension. The second photograph of the bridge illustrates how a structure such as this can help to define the space in the sky. One also notices how the frame, receding in perspective, leads the eye towards two trees in the distance. The bridge seen from this angle provides a frame within a frame, and distracts our attention from any detail in the

43 Bridge at Tilstock, Shropshire. (a) Seen from this angle the structure is evenly balanced. (b) Here the framework of the structure isolates fragments of the landscape. (c) In its raised position the bridge makes a disturbing diagonal line which leads the eye out of the top left-hand corner of the composition.

foreground. The final photograph in the series shows the bridge in a raised position – notice how the strong diagonal emphasis of the line breaks up the balance of the composition, and leads the eye out of the top left-hand corner.

The structures of natural forms such as trees and rocks, etc., are sometimes best seen in silhouette, especially when they help to define or frame facets of the land or sky.

b

Rhythm, Line and Continuity

The landscape we occupy is in a continuous state of evolution. The fact that we sometimes feel the need to identify with a particular place, and to express those feelings through the medium of photography, has something to do with our recognition of the way in which we have been moulded by similar forces, and as a consequence, we feel a much closer affinity to landscape than we do towards other subjects.

Rhythm is one of the most important elements of landscape photography – we make no apology for constantly reminding the reader that nature is vibrant and dynamic, it is never still. The rhythmic element in a composition is usually contained by surrounding forms and structures. There are numerous examples of the way in which rhythm is a dominant element in painting and in photography. In painting perhaps the most obvious example is the later work of Vincent Van Gogh. These paintings are full of rhythmic impulses and vibrant energy – waves of corn, cypress trees, and fast-moving cloud, are represented by a rhythm of opposing brush strokes which give a sense of movement. The strongest rhythmic forces in landscape are usually undulations and folds in the land which are caused by the underlying faults in the rock base. Other rhythmic elements in landscape are the many rivers meandering through valleys, paths, fences, walls, tree plantations, crops and the patterns made in the soil by the blades of the ploughshare. Some rhythmic patterns, however, are not always so conspicuous – the settling of dust which might be illuminated only by a ray of light, the gentle rippling surface of a pond, the gentle movement of sea mist in early morning – there are all kinds of more subtle rhythmic forces at work in nature. The more perceptive landscape photographers such as Minor White, Wynn Bullock and Raymond Moore, have consciously attempted to register the flow of life forces which are barely perceptible to the human eye.

44 Rivers, when seen from the top of a hill, make an incisive rhythmic line through the landscape.

45 'The Poetic Motive In Nature,' by Mario Giacomelli, 1959. The photograph taken from a high vantage point accentuates the rhythmic quality of field patterns.

46 This photograph of a Derbyshire valley is enlivened by the vigorous line of the drystone wall.

Rising diagonal movements are the most difficult to deal with in terms of pictorial composition – as already illustrated in the example of the raised cantilever bridge. A disturbing imbalance occurs, and the eye tends to wander out of the edge of the composition. The dynamic force of diagonal lines can sometimes be counteracted by a series of verticals (trees on a steeply rising hillside for example). The rising diagonal line is usually most satisfactory when it follows a visual path from the bottom left-hand corner of the composition to the top right-hand corner.

The linear elements in a composition are not always continuous; the horizon line, for example, might be interrupted by the rising and falling contours of the land mass. Where a line is broken, as with a group of trees planted at identical distances apart, the eye will automatically link them together as a continuous line, because we are able to visualize the connections. There are various qualities of line in landscape composition, ranging from the line which might sharply delineate a range of mountains when the light falls behind them, to the more dominant linear patterns made by mechanized farming techniques. One should consider the point that lines of varying degrees of weight and length might add interest to the composition generally.

47 Field study. The hedgerow makes a strong rythmic line as it follows the contours of the land.

SEQUENTIAL PHOTOGRAPHY

The photographer has a distinct advantage over the painter, in the speed with which he can build up a sequence of images related to the same theme. He is able to present a profile of a place as it appeared at a particular point in time. Each photograph in a sequence is a kind of stepping-stone towards a more total understanding of the place. The Dutch photographer Jan Dibbets can show, in a sequence of photographs, how the tide gradually rises towards the low-lying land of the Dutch coastline. A single photograph of a fragment of a landscape scene is an authentic record of that piece of landscape, but it also refers to the land on either side which has not been included. A single photograph may not present us with enough information about a particular place or region, and

there are photographers who have a deliberate policy of working sequentially, even if some of the images are finally omitted. Minor White said that by engaging a sequence of images, 'we keep in mind the photographs on either side of the one in our eye.' He also felt that when one is looking at a sequence of photographs of the same place, the meaning appears in the space between images – 'a sequence of photographs is like a cinema of stills. The time and space between photographs is filled by the beholder, first of all for himself, then from what he can read in the implications of design, the suggestions springing from treatment, and any

48 Sequence of four photographs gradually revealing the detail of the flint buildings as the camera is moved nearer to the subject.

97

c

d

symbolism that might grow from within the subject itself.'

There is a strong anticipatory element in the gradual build-up of a sequence of photographs which is not present in a single frame. The human sense reacts to the gradual revelation of images where each individual photograph provides a link to the next.

LIGHT

Every landscape photograph whether good, bad, or indifferent, exists by virtue of the scale of gradations of light that can be registered by the medium. We are often more attentive to the representation of an image than we are to the influence of light. Our awareness of light is usually precipitated by a sudden incident – sunlight pounding the clouds like an axe, a ring of bright water created by a shaft of light piercing dense cloud, or perhaps the subtle quality of light which filters through the thick-set branches of the trees in a forest.

In the historical survey we saw how early landscape photographers were acutely aware of light as the primary agent of photography. In the contemporary world, however, our channels of sensitivity towards the perception of light have become blocked to some extent by our dependence on, and acceptance of, artificial sources of light. With the aid of electricity, and the neon tube in particular, day is extended into night, and sunrise is no longer quite the daily spectacle that it was for our forefathers. It is not enough, however, that we should simply acknowledge the dependence of the photographic medium on light – we must also try to use light creatively. One quality that distinguishes a good landscape photograph from a casual snapshot is the degree of control that the photographer has exercised, in manipulating the light source, to produce exactly the right balance of tone.

Film, both black and white and colour, registers light values which are very different from the sensation of light as perceived by the human eye. In landscape photography it is particularly important that we should consider the colour and tonal qualities afforded by different types of film, and the conditions of light under which they will be used. Black and white film, for example, is sensitive to blue-tinged light, and less sensitive to red tones. Therefore in photographing a landscape subject, the sky which we see as an intense blue might, when registered on black and white film, appear as an uninteresting blank white shape. This apparent discrepancy between what is perceived by the eye, and the tonal range which can be retained by photographic film, can be partly compensated for by filtration, and by the use of different types of film.

Light is a form of energy which stimulates visual perception. Waves of light which we call photons will travel freely until they are interrupted by solids in the atmosphere or on the land. There are different kinds of light wave – the intensity and brightness of which can be determined by the height and length of each wave, and by the confinement of light waves to certain directions or to a particular plane.

All light waves are conditioned by the way that they react to various substances – cumulus cloud, water, metal, humidity and so on. Even in direct sunlight, the actual intensity of light would vary considerably from one part of the landscape to another. The degree to which a wave of light reaches the surface of the land is dependent on a number of factors – the amount of man-made pollution and carbon dioxide in the air for example, and the quantity of dust in the atmosphere, or the density of cloud. The measure of light is also affected by the position of the sun at different times of the day. At sunrise or sunset there is a scattering of light caused by molecules of air, and by the presence of dust and moisture in the atmosphere. When the sun is overhead at midday, the light waves have a shorter distance to travel than at dusk, or at early morning when the light has to penetrate air molecules over a greater distance, causing a wider scattering of light. It is because the red and yellow wave-lengths travel the farthest, that the sun in early morning and early evening takes on a rich ochre-red hue, which is especially beautiful when it tinges thin layers of cloud. At sunrise and at dusk, the over-all illumination is less intense, and the quality of light more even, so that the contrast between light and dark areas of landscape are correspondingly much softer.

It is not always necessary to wait for perfect conditions of light to take landscape photographs; some extremely good photographs have been produced in poor conditions of light and in extreme conditions of climate. The same landscape view

49 *Overleaf:* 'Light on the Earth,' by Mario Giacomelli, 1959. A fine example of the way in which the photographer has harnessed the light to produce dramatic contrasts in the composition.

can undergo a considerable number of changes in the course of a single day – particularly in the northern hemisphere, where the light values are constantly shifting from hour to hour. It is the photographer's task to decide on the right time of day, to obtain the quality of light most suited to the subject. An obvious example might be the Grand Canyon, which is undoubtedly best seen at early morning, or at sunset. At these times there is an incredible range of softly muted colour, which is lost in the intense glare of the sun at midday.

a

50 Fiesole – light and shadow. (a) The shadow on the steps leads the eye into the composition. (b) The light source is partially concealed by the gateway and the trees.

Refraction and Reflection

When a transparent object interrupts a ray of light, the direction and speed of light are adjusted accordingly – this phenomenon is called refraction. An opaque object similarly placed would send the ray of light back in the direction whence it came – this is reflected light. Clouds are made up of composite droplets of water which are transparent – the fact that they appear to be opaque is due to refracted light.

A landscape scene reflected in the still water of a lake or river can enhance greatly the compositional balance of a landscape photograph (see p. 153). Mirror images of landscape forms need to be handled with care, however, and as a general rule the composition works best when there are few elements included. The quality of light when working with reflective surfaces is of the utmost importance – the atmospheric qualities of early morning or evening provide the softer contrasts of

tone which better express the sense of tranquility. At certain times of day the intensity of reflected light from the surface of water can greatly influence the luminosity of the scene generally. A sudden breeze can distort the symmetry of the mirrored image, so that the previous sense of stillness is destroyed. Where a river or lake features in a landscape view, it is necessary to move around to find the best position to include both the main forms and their reflected image, within the confines of the viewfinder. One should try to avoid cropping any part of the image which might destroy the harmony of the composition. A landscape view which includes a large expanse of water often works best when one is photographing against the light, particularly if the sun is partially concealed or filtered through the foliage of trees. A polarizing filter is useful for eliminating unwanted reflections. One should take extra care to avoid unnecessary flare when the light is particularly

51 Coast of Kobe, Japan, by Aart Klein.
The course grain of the image heightens the
atmospheric quality of the composition.

bright on reflective surfaces. It may be necessary to balance light readings on the meter between the brightest part of the scene and the darkest.

WORKING IN CHANGING CONDITIONS OF CLIMATE

In northern Europe, every season offers the landscape photographer a fresh viewpoint – perhaps the most characteristic feature of the English landscape is the complete unpredictability of the weather pattern which changes radically from season to season, day to day, and sometimes from hour to hour! In southern Europe and in the southern states of the USA the light is more intense, and landscape forms are more sharply delineated against a clear sky. Yet in every region, no matter in what country one finds oneself working, there is a certain season and a certain time of day when the quality of light and the climatic conditions are most suited to reveal the intrinsic qualities of that particular piece of land. The rugged landscape of the North Yorkshire Moors in England, for example, might look best when photographed under snow. The photograph by Denis Thorpe (see p. 164) shows how snow has transformed the Yorkshire town of Hebden Bridge. Lowland regions often look best immediately after a rainstorm, when the hills are glistening with moisture. Some photographers are prepared to wait many months for exactly the right conditions of light and climate, and their patience is usually rewarded with a photograph which transcends the casual snapshot view.

52 A heavy fall of snow will sometimes reveal landscape forms which might otherwise remain unseen.

COLOUR PHOTOGRAPHY

The ability to render colour in landscape photography increases its versatility, but it is not an end in itself. Sometimes it is helpful to use colour in order to make one's point; for instance, colour photography is an excellent medium for dealing with the qualities of light and atmosphere. If, however, one merely produces photographs which happen to be coloured, then the results will not be any better and, indeed, may very well be inferior to an ordinary monochrome print.

Colour must be exploited; it must be composed and controlled like the other elements in a photograph. Above all, it must be treated with delicacy and restraint. Simply because a subject exhibits vivid hues or exotic colour relationships does not mean that it will provide a good photograph; in fact, the opposite is often true. This is not to say, of course, that a mixture of bright colours should never be used (it all depends upon the point which one desires to make); it is simply to suggest that

such subtle, muted colours as are produced, for example, by rain or mist on the landscape, are ideally suited to colour photography. Also it is easier to control a restricted range of colour.

Two points which it might be useful to consider are, first, that since differences in hue will help to distinguish one form from another, there is less need for tonal contrast than in black and white photography. And, second, that colours will often seem to be more intense in the photograph than was apparent at the time.

Recent developments in the techniques of colour photography have made it possible to record landscape colours with a much greater degree of accuracy than was previously possible. This is particularly true of the cibachrome process, which renders much more luminosity and comes near to the qualities obtained by colour transparencies. The more delicate gradations of colour, however, are sometimes lost or levelled out in the processing. The brightness of certain col-

ours (notably blues and reds) tend to be overstated in colour-processing techniques. Whites are difficult to register; and the areas that are meant to be white on a colour print are often tinged with green or blue.

The many refinements in full-colour reproduction in books and magazines, and even the comparatively crude reproduction of colour in television, have made us much more aware of colour generally. Whether such influences have been entirely beneficial is open to question; we still, for example, experience difficulty in distinguishing between lighter and darker intensities of colour.

Our attitudes to colour have been conditioned to some extent by Newton's discovery at the end of the seventeenth century, that white light passed through a prism projects seven coloured rays: violet, indigo, blue, green, yellow, orange and red. The result of the simple experiment was to form the basis for an entirely new system of colour theory.

There are three main qualities in colour perception – hue, tonal value, and chroma. Hue is the quality by which we differentiate one colour from another – vermillion and crimson are different in tone, but the hue of both colours is red. Similarly when a red/orange colour is seen next to a red/yellow colour, the hue is balanced between the two. When colour is diluted by the addition of white, it remains a tint of the same hue. Tonal value refers quite simply to the degree of lightness or darkness, and the chroma refers to the degree of brilliance in colour.

8 Aspects of the Landscape

The landscape which we occupy is to a large extent of our own making, and the imprint of man is usually conspicuous in our everyday visual experiences. Man has adapted his environment from very early times. He has cleared forests (and planted them), drained marshes, flooded valleys, ploughed the land and established pasture. He has created buildings, roads and boundaries. The impact of man on nature has varied, of course, from place to place. Where the climate is warm and food abundant, there is less need for change than where crops must be grown and shelter from the weather provided. The North American Indian, being a hunter, was likely to make less of a mark on his territory than, say, a Dutch farmer who had to drain and cultivate his land.

In a small, densely populated country like Great Britain, it is virtually impossible to look upon a scene that man has had no hand in shaping. Even remote moorland, for example, can owe its appearance to man's efforts. Grouse often inhabit the moors and they prefer young tender heather. In order to encourage new growth, the landowner will burn down the old, woody heather in carefully controlled and rotated patches.

There has always been change, and change has always been resisted. The patchwork-quilt pattern of small fields which seems so typical of rural England is largely the result of the Enclosure Acts of the eighteenth and nineteenth centuries. Before the eighteenth century, the land had been farmed under the open-field system and the implementation of these Acts caused a radical and rapid transformation in the appearance of the countryside. At the time there was much resentment among artists, poets and country-lovers. A local historian said of the Welland Valley: 'to ditch it and quick it for inclosure, with offensive intersecting lines, would destroy the finest monument of what this country has been.' In time, of course, the containment of the land has come to be accepted as an integral feature of the English landscape. And, ironically, protests are now being made about the removal of the same walls and hedges. Increasing mechanization in agriculture has led to the need for larger tracts of land – almost a return to the medieval open field. And yet, boundaries, once established, are difficult to get rid of, primarily because of people's resistance to change. We should not, however, think of the land as a museum piece. For the most part, the landscape is subject to continuing change.

It was also in eighteenth- and nineteenth-century England that the Industrial Revolution took place. The transition from an agricultural economy to one based on industry had a profound and far-reaching effect, not only on social and political life but also on the landscape. There was an increased shift of population from the country to the towns. Factories were built, roads were improved and canals and railways were constructed. The casting of iron on a large scale made possible all sorts of new structures. Contemporary reaction to all this varied, but was usually strongly unfavourable. Wordsworth, for instance, demanded 'Is there no nook of English ground secure from rash assault?'

Owing to the need for a supply of running water, many of the early mills and factories were established in beautiful and hitherto unspoiled valleys. Abraham Darby built his ironworks in Coalbrookdale. While one observer found the vision sublime, it moved another poet to write of the violation of the dale by 'tribes fuliginous' who 'invade the soft, romantic consecrated scenes.'

Joseph Wright of Derby found Arkwright's mill at Cromford in the Derwent Valley worthy of painting by day and night. But it must be remembered that the local millowners, Strutt and

53 Landscape of 'Le Langhe,' Piemonte, Italy, by Augusto Rosso, 1978.

54 Enclosed fields on the Shropshire Plain – it is difficult perhaps for us to visualize this scene as it would have appeared before the introduction of the Enclosure Acts.

Arkwright, were among his most important patrons.

The landscape photographer is concerned primarily with the appearance of things, and yet although he need have no special knowledge of geology, agriculture, or the historical development of the land, his response to what he sees may well be affected by his appreciation of what causes the scene to be as it is. As Constable said, 'we see nothing till we truly understand it.'

THE NEW LANDSCAPE
In smaller industrial communities such as Great Britain, the effects of industrialization are particularly apparent. Thousands of acres are lost each year to housing, motorways and industrial

estates. There is a strong temptation particularly among artists and others with above-average visual awareness, not only to condemn out of hand but also to trace the evil back to the early 'rash assaults' upon the countryside. But it may be that it is simply the scale and speed of change which has becomes so frightening.

The hand of man upon the land is not necessarily destructive. When the shepherd builds a drystone wall to contain his flock, or the Italian farmer cuts terraces into the hillsides to cultivate his vines or olives, they are implanting structures on the landscape which may be visually very satisfactory (as well, of course, as being functional). A visit to Coalbrookdale or Cromford today will show how time has softened the relationship between the

55 The world's first iron bridge erected by Abraham Darby over the river Severn in 1779.

56 One of Arkwright's mills near Cromford, Derbyshire.

artefacts of early industry and their respective valleys. Indeed, it often happens that the best functional architecture of any age provides a dynamic element in what might otherwise be considered a rather mundane landscape. The railway viaduct and the radar station may well complement their physical location. The emergence of industry, however, is not limited to the appearance of factories, mines and quarries. The concentration of the population in cities, and the enormous increase in the efficiency of transport, have had very far reaching social effects. These changes of course, have been reflected in the work of artists. Gustave Doré, for instance, in his London townscapes, makes a social comment on urban life in the nineteenth century. Turner, in his 'Rain, Steam and Speed,' communicates an aesthetic pleasure at the sight of a steam train moving rapidly through the countryside.

The industrialization of the landscape is a continuing process which, it seems, can neither be halted nor remedied. In Great Britain the enor-mous escalation of population density since the nineteenth century has made it necessary to encroach on hitherto 'undeveloped' areas of land, in order to create dormitory towns for the larger cities.

The shift of the population from the rural areas into the towns, which increased in the eighteenth and nineteenth centuries, still continues. Only a small percentage of the labour-force actually works the land; in Great Britain it is as low as 3.5 per cent, and in the USA it is 6.4 per cent. The necessity of providing food for the ever-increasing population has resulted in a situation where we now have almost outstripped our natural resources. By using artificial fertilizers and chemical sprays we are able to bypass the conventional system of rotational farming, in order to extract more food from the land. Changing techniques in arable farming and animal husbandry have had, of course, a marked effect on the appearance of the countryside. Occasionally the effect has been catastrophic – and dramatic. The change from cattle rearing to wheat growing in the American middle-

west states of Colorado, Kansas, Oklahoma and Texas led to the erosion of the top-soil, the creation of the 'dust bowl,' and the ruin of the poorer farmers and farm labourers. This desolation became the subject of some extraordinarily beautiful and poignant landscape photography by Dorothea Lange in 1938.

Apart from the obvious factors which have contributed to the shaping of our modern landscape – the growth of industrial cities and the creation of railways and road systems, there has been the more subtle influence of the use of land for leisure activities. Throughout the Western world, tourism and leisure have become major industries, and at the height of the summer season there is a mass exodus of people from towns and cities to countryside and coast. In the coastal regions, the annual influx of holidaymakers crowd the beaches and roads, and collectively transform many of the smaller resorts into vast playgrounds. At Land's End in Cornwall the grass on the clifftop has almost worn away, and even on the high moorland of the Pennine Way the erosion due to large numbers of walkers is so severe at one point that plastic matting has had to be put down to protect the land.

Country parks have been created in many European countries and in the USA to enable town-dwellers to enjoy their leisure in the open air. In England, the Countryside Act of Parliament defined the country park as: 'a park or pleasure ground for the purposes of providing, or improving opportunities for the enjoyment of the countryside by the public.' Many such parks have marked-out routes for walkers called 'nature trails' – the motorist parks his car, collects a leaflet from a warden, then proceeds to follow a series of numbered posts over the designated route. Leisure activities, like any other major industry, are subject to corporate planning techniques: a walk through the forest can become a package tour which makes no demands on personal initiative.

Contemporary landscape photographers have tried to find new relationships between the natural elements of the countryside and the man-made structures of a technological society. The siting of nuclear power stations, oil refineries, radio-telescopes, radar stations, or television masts in otherwise undeveloped areas results in a juxtaposition of industry and nature which, while repugnant to many, may provide the photographer with visually interesting phenomena worth recording. It is not the function of the landscape photographer simply to seek out unspoiled scenes and then to record them as carefully as possible.

Nonetheless, this book is essentially concerned with the photographing of the kind of landscape that is still relatively free from inroads made by industrialization and urban development. For those of us who have to live in towns and cities, it is

a

b

57 Man-made structures. (a) Radar systems in Fylingdales, Yorkshire. The giant domes looming on the horizon present something of a visual shock to the casual visitor travelling on the lonely moorland road. (b) Newton's telescope at Hurstmonceux, Sussex. An installation of this kind tends to punctuate the landscape, thus adding a point of interest.

not so easy to find subject matter for landscape photography amidst the mish-mash of an urban estate. There are photographers, however, who reject the purist notion of straight landscape photography, and prefer to come to terms with any environment in which they find themselves. In fact, there are interesting connections to be explored between natural forms surrounded by street furniture. Some fine examples of landscape photography have also been produced in unkempt city parks or in those places where industry and landscape are seen in an uneasy alliance. A factory or warehouse, a viaduct or furnace chimney, can prove to be a vital element in an otherwise dull scene.

The town-dweller may make frequent visits to the countryside, but for most of the time he must contend with his usual surroundings. The photographer can react to an urban environment in different ways; photography can be a useful vehicle to express one's feelings about the continuing erosion of the countryside by industrial development, roadbuilding and so on. Alternatively one might simply see things purely in visual terms – a

58 Where industry and arable farmland meet, as at ICI, Wilton, Teesside. The cooling towers and flare-stacks can provide the landscape photographer with some interesting visual material.

114

petro-chemical plant encroaching on a cornfield can be extraordinarily beautiful! Even nuclear power stations can be visually pleasing, and no doubt the space age will have its own horrors to contribute.

Much of the discussion about landscape in this book refers specifically to England: it has often been said, however, that the English landscape is a microcosm of landscape features throughout the world. The variety of the English landscape is unsurpassed in relation to its size as a country. In the time it would take to fly the length of the Rocky Mountains, one could encompass most of the varied physical features of the British Isles. Mountains are not particularly high, rivers are narrow, there are no really vast plains or great expanses of forest. There are no panoramic views which compare with the awesome grandeur of the Alps, the Himalayas, or the Grand Canyon, yet there are changes in the character of the English landscape almost every few miles. The qualities which make it different from that of other countries are not easily defined. Because of its diversity, it is more difficult to perceive in terms of separate categories

59 Dungeness. The way that the various elements are disposed in this area of reclaimed land has surreal connotations.

of landscape. The craggy landscape of the north is vastly different from the soft undulating chalklands of the south – the marshy fenlands of East Anglia contrast sharply with the more mellow landscape of the West Country.

But landscape is not made up merely as the result of some haphazard arrangement of valleys, hills and rivers; the physical features of each region relate to a precise geological system which underlies their distribution. Generally speaking most areas of landscape in England are comprised of sedimentary rock, which during the passing of time have become fragmented and distorted as a result of gradual movement in the Earth's crust. The edges of massive rock formations protrude through the surface at different angles, thus providing a variety of shape and form in the landscape. To geologists this sequence of change can be related to a time scale; the landscape photographer, however, need not concern himself with precise geological details. It is sufficient that we are aware of the fact that we are arresting for a moment, a fragment of landscape that is in a continuous state of evolution.

The work of certain writers, poets, painters and photographers is inextricably linked with a par-

60 and **61** The remains of tin-mine workings, Botallack, Cornwall. The remnants of a defunct industry can be quickly assimilated into the surrounding landscape.

116

ticular place or region. We refer to parts of East Anglia as Constable country, and Thomas Hardy used Dorset as the setting for his stories. The small inlet of Laugharne in Wales inevitably brings to mind Dylan Thomas's 'Under Milk Wood.' Landscape photographers too have identified with particular regions; in England, photographers such as Paul Nash, Bill Brandt and Fay Godwin, have at different times and for different reasons been closely associated with the chalkland landscape of southern counties. While some of Raymond Moore's most memorable landscape photographs were inspired by the scenery of the Gower peninsula in Wales.

While there are some photographers who prefer to work fairly closely within the confines of a particular locality, others, like nomads searching for an oasis, travel from place to place without knowing exactly what they are looking for. This, of course, is a continuation of the tradition in topographic documentation. Today, however, many younger photographers are more objective in their approach, and tend to focus their cameras on the ordinary, rather than on the grandiose.

62 The IBM Building, Cosham, designed by Foster Associates. A rare example of a building where the architects have related their design to surrounding landscape forms, producing a structure which is visually complementary. Photograph by Richard Einzig.

63 Hardy's Wessex.

THE PRIMARY ELEMENTS OF LANDSCAPE

The Sky

The sky, more than any other element, can greatly influence the mood or drama of a landscape view. Further, it is an element of landscape which is constantly changing – ponderous clusters of cumulus clouds break, accumulate and disperse. Even a cloudless sky changes dramatically in appearance from dawn to dusk, depending on the intensity of light at different times of day.

It is surprising though just how many photographers fail to recognize that the sky *is* an integral part of a landscape composition in photography, as in painting. It is not merely a white backcloth against which other forms are seen. The English painter, John Constable, in a letter to the Rev. John Fisher, says – 'I have done a good deal of skying,' and he continues, 'the landscape painter who does not make his skies a very material part of his composition neglects to avail himself of one of his greatest aids.' In many ways Constable felt that the sky was the key note in his painting and determined the mood or sentiment of the total composition. Photographers such as Stieglitz, and many photographers since, have demonstrated how the medium of photography is uniquely placed to register the imponderable nuances of cloud and sky. In his book *Modern Painters*, Ruskin includes a section, 'The Truth of Skies,' and describes with great care the various pictorial qualities that are evident. Of the clear blue sky, he says, 'This is of course the colour of the pure atmospheric air, not the aqueous vapour, but the pure azote and oxygen, and it is the total colour of the whole mass of that air and the void of space.' He then goes on to describe in great detail the symmetry of cloud structures, and the way their edges are defined. Rain clouds are compared with storm clouds and so on.

In the section on composition (pp. 85–6), reference was made to the position of the horizon line, in relation to the land mass and the sky. In general, where the sky is the most interesting and important element in the composition, the horizon line should be kept fairly low. When using a normal panchromatic film, filters are sometimes needed to register some of the more subtle variations of light and tone – a yellow filter will make the cloud appear lighter against the sky, and a red filter will render even greater contrast of tone. The effects of halation (caused by the light which, having passed through the layer of emulsion on the film, is then

64 Cloud study taken on the Aran Islands by Guy Ryecart. An example of how the photographer has had to wait for exactly the right time of day and the right quality of light to produce sufficient contrast between the land and the sky.

reflected back from the film base, thus producing a white halo effect at the edge of darker tones), can be avoided by photographing the clouds when they conceal the sun. The use of filters will also reduce the risk of halation. A yellow-green filter will tend to darken the blue of the sky whilst making any greens on the land surface much lighter, and therefore increase the amount of contrast between land and sky.

65 Cloud study, Shropshire Plain. The tones in this photograph are more even than those in no. 64; only the small group of trees on the left side of the composition strike a dominant note.

Rocks and Weathered Surfaces

The richly textured surfaces of rocks and stones are the result of centuries of continual pounding by the elements – wind, rain and sea. Rivulets of water which run continuously over the surface of rock have the effect of softening the form; extremes of temperature cause fissures and the rocks break down into smaller segments. Rocks are composed of aggregated solid matter, usually combining one or more minerals. They are divided into three main categories: sedimentary rocks, made from the compacted debris on the Earth's surface; metamorphic rocks, which are formed by heat and pressure on existing rocks; and igneous rocks, which come from within the Earth's crust.

While the geologist is able to recognize and codify the particular categories of rocks and minerals which distinguish one region of landscape from another, the photographer is concerned mainly with an appreciation of their visual qualities. The late Barbara Hepworth, whose sculpture one associates with the gaunt granite-based landscape of Cornwall, often said that she felt her work was closely tied to the physical features of her homeland. The sculptor works directly with stone, of course, but the tactile qualities of rocks and stones are difficult to express in terms of drawing and painting. Photographers such as Minor White and Raymond Moore have demonstrated how photography is better able to

communicate those qualitites.

The colour and texture of the soil of a particular region is also influenced by the base-rock; the presence of chalk, for example, has the effect of neutralizing the colouring of the topsoil, while a sandstone base-rock gives the surface colouring a rich red tinge.

The effects of climate on various surfaces are often conspicuously evident in coastal regions, where the erosion of metal, stone, wood and other material is hastened considerably by the moist

66 Outcrop of rock on the Derbyshire Dales.

salty air. Iron surfaces are especially vulnerable and break down rapidly; as each layer peels away from an iron sheet, it rapidly disintegrates. Wooden surfaces react in an interesting way to the constant burnishing of the sea tides; the texture of the wood becomes sponge-like, retaining moisture which eventually hollows out the grain to a cell-like structure.

125

67 Disused quarry at Stiperstones, Shropshire.

68 Detailed study of rock outcrop in Cornwall
showing weathering and surface growth of lichen.

69 Rocks of the Aran Islands, by Guy Ryecart. The photographer has used the linear diagonal structure of the rocks as an integral part of his composition.

Trees

The predominant shapes and contours in landscape are horizontal. Trees, when seen individually or in groups of two or three, provide the most noticeable vertical element. They have the effect of arresting movement, and help to create a sense of balance and harmony to the scene generally. But we should not think of trees merely in the context of being useful devices for composition; seen individually, the immense variety of different species presents sometimes exquisite, graceful and strongly rhythmic features. Each tree has its own individual character, whether a young sapling or an ancient oak.

When photographing a single specimen, one should take as much care as one would devote to a studio portrait. It can sometimes happen that a tree which appeared to be full of interest, at the time of taking a photograph, can turn out to be dull and lifeless in the resulting print. Whatever kind of specimen you choose to photograph, make sure that you are working under the best possible conditions of light. The modelling of the light and dark areas of the foliage needs sufficient contrast to render the fullness of the form. Certain specimens of deciduous tree, horse-chestnut for example, might be best photographed in midsummer when its full bloom of foliage lends a voluminous quality to the scene. The gaunt tracery of an elm tree, on the other hand, might look more dramatic when seen against a dark winter sky. The shadow and patterns of light cast by the form of the tree are also important, as is the relationship of the tree to surrounding elements.

Again, one should try to eliminate such unwanted intrusions as telegraph wires and the like. But remember that one of the most common errors made when photographing single specimens is the tendency to crop too much of the outer edges of the foliage. One should try to encompass the total shape of the foliage within the limits of the viewfinder. Alternatively if one is only interested in a small facet of the tree structure – the texture of the bark or the play of light on certain branches, for example – then one should get much closer to the subject. There should be sufficient contrast of tone between the foliage, the trunk and branches, to make the use of filters unnecessary.

70 Tree studies, San Gimignano, Italy. Notice how the towers provide visual equivalents to the vertical structure of the trees.

71 *Left:* Study of an olive tree – the strongly calligraphic shapes of the branches are repeated by the shadows that they cast.

72 The continuous line of cypress and olive trees is intersected by the dominant vertical line of the tree in the foreground.

PATTERN AND TEXTURE

Taking photographs is dependent on our response to essentially visual phenomena, yet it can also stimulate our sense of touch, smell and sound. It is possible to take photographs which can re-create visually a tangible quality, can conjure certain smells and noise or silence.

Texture is an important ingredient in almost every aspect of photography, but more so in landscape photography. We are sometimes so preoccupied with the representation of the image in terms of tonal contrast and composition, that we tend to overlook the rich textures of various substances, which may have been burnished and weathered by centuries of exposure to the elements. A photograph of Stonehenge seen in silhouette would present a dramatic enough image,

yet without revealing the characteristic texture of the giant stones, the photograph would be lacking its most vital ingredient. The photograph by Emile van Moerkerken (see no. 73) is of similar giant stones which are to be found in Brittany, France. Notice how the texture of mottled lichen on the tall stone in the foreground relates to the texture of the grass, and to the softer, more even tones of the sky.

The current trend amongst some photographers for producing photographs of strongly contrasting tones is often done at the expense of retaining the finely graded half-tones which are necessary to reveal the full textural qualities of a landscape scene.

The fine focus of a close-up lens enables us to record detail and intricate textures with a degree of

73 Ancient stones, Brittany, by Emile van Moerkerken. This photograph is a good example of the way that texture can play an important part in the composition.

accuracy that is not to be found in any other medium. In this way photography has increased our knowledge and understanding of the tiny facets of natural forms which are barely perceptible. There are photographers who have concentrated almost exclusively on producing close-up photographs of textural surfaces, rather than concentrating on the wider view of landscape. Working in this way they become much more integrated with landscape forms, and perhaps they learn a great deal more than those who choose to work at a discreet distance.

The furrowed pattern made by a tractor dragging a ploughshare through the soil is an obvious example of the way that texture and pattern can greatly embellish a simple landscape view. The changing patterns of landscape relate to the natural cycle, and to the cycle imposed by the rotational farming system. It is always interesting to see the

way in which the pattern of a single field can change during a year: the combed texture of autumn ploughing and seeding, the appearance of the first green shoots of corn, the wave-like sea of the fully grown crop which turns eventually to a rich ochre colour. Then follows the dramatic effects of harvesting, the burning of the stubble, and the completion of the cycle with reploughing. With the same regularity the deciduous tree sheds its leaves in autumn, revealing the dark skeletal structure of its branches; the first buds of spring appear, and the branches are soon concealed once more. By late summer the boughs become so heavy that only the autumn winds can relieve their burden.

This process of continuous change provides an endless source of inspiration for the photographer,

74 and **75** Field patterns made by ploughing.

whether the patterns on the surface of the land are man-made, or simply part of the natural cycle of growth, gradual decay and replenishment. For the photographer working primarily in black and white, the transient patterns of light and shadow provide the most interesting patterns; a continuous pattern of shadow can often provide a unifying link between all the other elements in the composition.

It may be a useful exercise for the photographer approaching landscape subjects for the first time to use at least one roll of 35mm film to produce a sequence of images which concentrates purely on the textural qualities to be found in landscape. Working within the self-imposed boundaries of a small area, one can gradually build up a variety of images which might present a more total understanding of the place than can be gleaned from a general landscape view taken from great distance. When a surface texture appears within the limits of the viewfinder, it is already isolated from its relationship to adjacent forms, and seen in isolation, the photographic image of that fragment of landscape takes on a new significance.

ARCHITECTURE IN LANDSCAPE

The term 'architecture' here is used in the broadest sense, to include not only a manor house or similarly imposing structures, but also more primitive buildings such as hay lofts, barns and cattle shelters.

Architectural photography demands contrast; the three-dimensional qualities are best expressed by the way that light can sharply define some surfaces, whilst others remain in deep shadow. The contrasts of light and shade are more critical with architectural subjects, than with the more gentle landscape forms. The light and dark areas of the subject should not be too evenly balanced; either the surface which reflects the most light, or that which is in shadow, should predominate according to the type of structure, and the atmosphere of the place generally. The relationship of the building to the surrounding landscape should be carefully considered, not just in terms of composition, but also in terms of tonal values which best express the mood of the subject.

A single white cottage on a rain-soaked Welsh hillside, the façade of a medieval cathedral in direct sunlight, a farmhouse shrouded in mist – such dramatic contrasts will only work if the conditions of light are exactly right. Direct sunlight can make a building appear conspicuous in the landscape,

whereas the softer quality of light filtered through cloud can provide a much closer tonal unity between the building and other landscape elements.

At one time it was easy to recognize the geological features of a region by the variety of stone, clay or timber used in the construction of domestic and religious architecture. Sandstone, limestone, granite, flint and slate, were quarried locally and used extensively in rural communities. Many fine examples survive, but present-day corporate methods of 'system building' have made it increasingly difficult to identify purely regional

76 and **77** Buildings made from local materials: Stokesay Manor and church.

styles of architecture based on local materials.

In England the best examples of architecture which incorporate the use of local materials are the parish churches; almost every village and town can boast a church built from local stone or timber. In the USA and to some extent in Australia, some of the finest examples of architecture built from local materials are the many timber-framed haylofts, barns and weather-boarded churches.

Ruskin believed that the authenticity of landscape painting depended on some kind of reference to man. Looking at the scarred face of the land today, we can trace to some extent the chronology of human existence. Ancient monuments such as Stonehenge or Avebury still hold a particular fascination for photographers. The main difficulty in trying to photograph such well known landmarks, however, is that they have become part of the established tourist itinerary. Consequently one is forced to work either at dawn or dusk, or out of season. Some people are attracted not just by the visual properties of ancient stone circles, but also by the air of mystery and superstition which surrounds them. Perhaps one reason for this might be that as people become more disillusioned by the values of a civilization which has turned its back on nature, so they tend to seek refuge and a sense of permanence in the past.

Nineteenth-century architecture was forthright in its geometrical simplicity, embodying as it did the dignity and grandeur of a diminishing empire. Cotton and woollen mills, pumping stations, watermills, viaducts and warehouses – all reflect the aspirations of the industrial age. When they were first erected in picturesque valleys, these industrial buildings were as odious as the cooling towers and motorways of today, but with years of grime and weathering they have become assimilated into the landscape. Likewise in Canada and in the USA, the giant grain silos and similar

nineteenth-century installations have become integrated with the land.

When photographing a building, the depth of field can be critical; a smaller aperture will, of course, render much better over-all definition. It may also be necessary to use longer exposures, so that the use of a tripod to avoid camera-shake is essential. A cable release is also useful for the same reason. Where a building is particularly high, say a church tower, there is a problem of distortion to be encountered. This can be overcome by using a camera which has a rising front. This type of camera has a lens which can be raised up or tilted, so that a greater proportion of the image at the top of the subject will register on the bottom part of the film – thus making unnecessary the need to actually tilt the camera upwards. Most of us, however, will have to make do with a standard SLR or TLR camera. The best way of avoiding too much distortion by camera-tilt is either to select a higher viewpoint or, if this is not possible, at least to use a wide-angle lens. Alternatively one can tilt the camera anyway, and correct any distortion of the image during the

78 *Left:* Net lofts, Hastings. First established in the sixteenth century, these lofts are a fine example of early functional architecture.

79 The towers of San Gimignano. Although only thirteen towers remain, they have been a dominant landmark in Tuscany since medieval times.

printing stage, by tilting the base-board of the enlarger on which the printing paper is placed.

LANDSCAPED GARDENS – WILD FLOWERS AND PLANTS

The reasons for the changing appearance of landscape have not always been functional or economic; the great landscape gardeners tried to impose on the unruly elements of nature what they considered to be a higher order.

English and American industrialists, returning from their Grand Tours of Europe in the nineteenth century, tried to emulate the architectural styles and gardens of Sansovino, Palladio and others. They were inspired by the formal symmetry of gardens such as Versailles. Superb examples of the grand designs for landscaped gardens are to be seen in the so-called 'red books' by Humphrey Repton, who 'improved' at least four hundred estates, many of which still exist today.

The formal aspect of large landscaped gardens provides considerable scope for the photographer, particularly in terms of composition. One should try to take in as much of the total plan of the garden as is possible within the constraints of the viewfinder. By concentrating on isolated details, the whole concept of ordered spatial relationships may

80 The gardens of Versailles. This was one of a series of beautifully composed photographs taken by Atget in 1903.

be lost. The gardens of Versailles when seen in perspective, for example, can be very stimulating in terms of classical composition, whereas a photograph of a single flower bed will convey nothing of the over-all grandeur of the place. The photograph by Eugene Atget (see no. 80) was taken at Versailles in 1903. The composition is deceptively simple; the intricate decoration of the urn on the left is defined by the darker tones of shrubs and trees. The eye travels from the urn along the white path to the far distance.

Other legacies of the nineteenth century include the many classical statues, examples of topiary, and the building of 'follies' – those delightful non-functional buildings which often employed fantas-

81 'Mad Jack' Fuller's Folly at Dallington, Sussex. Fuller's friends challenged his claim of being able to see the spire of the local church from his home, and proved him wrong. To remedy the situation he decided to build his own spire which *was* within sight of his house!

large area of lawn, an avenue of trees, or a white path, can all provide visual links in the composition. The use of a large object in the foreground can give an added sense of depth and a sense of scale.

Flowers, shrubs and plants of all kinds can present an endless variety of subject matter. If one intends to concentrate on single specimens rather than the general mass of blossom, then a set of extension rings is necessary. These allow closer focussing from a distance of 18 to 4 inches (45–10 cm). When using extension rings, a smaller aperture will ensure a sharper image.

Flowers really demand colour; the landscape photographer will be primarily interested in wild flowers seen in their natural habitat. When one is working with colour film, a field of poppies, lavender or mustard seen as a concentrated patch of colour, can provide the dominant chord of the composition. An interesting experiment is to use a long-focus lens; this has the effect of compressing large areas of colour into a rich two-dimensional pattern. The use of soft rather than hard focus can also greatly enhance the mood of the composition.

82 Plane trees in the Luxembourg Gardens, Paris.

tic design and building techniques.

A selection of lenses of different focal length are useful when photographing landscaped gardens, particularly a wide-angle lens. Also, since longer exposures might be necessary, a tripod and cable release are essential items of equipment. In addition to yellow and red filters, a green filter is handy when working with panchromatic film, since greens often register too darkly. The green filter has the effect of rendering tones lighter. A yellow-green filter for both foliage and sky is also favoured by some photographers.

The photograph of Versailles by Atget shows very clearly how the position of the camera is critical when photographing a formal garden. A

9 A Folio of the Work of Nine Contemporary Landscape Photographers

Ansel Adams
John Blakemore
Gianni Berengo Gardin
Mario Giacomelli
Aart Klein
Raymond Moore
Emile van Moerkerken
Guy Ryecart
Denis Thorpe

Ansel Adams

The work of Ansel Adams is inextricably linked with his love of the land, and in particular the Yosemite Valley, which he first photographed at the age of 14 with a box Brownie.

He picked up the basic techniques of processing and printing by working as an assistant to a print-finisher in San Francisco. Most of his vacation time was spent taking photographs in the Yosemite region. His early training as a concert pianist helped to form his ideas about composition and to develop his sense of judgement. Adams has in fact suggested that the discipline of these studies in music helped to establish confidence in his ability to work intuitively, but with a command of exacting technique. His feeling for composition was also behind the establishment of his 'zone system' – a means of balancing the diverse tones in a landscape scene to the exposure scale of the negative. This method of previsualising the tones by cross-reference from the subject to the exposure value of the film material enables him to determine fairly accurately the tonal balance of the print that will be made from the negative. He prefers black and white to colour, since the representation of colour, through a monochromatic range of tone, produces an image several times removed from reality. His mountain subjects are in essence monochromatic - the muted tones of the rock, shrouded in mist or snow-capped, seem to relate better to a tonal scale from black to grey and white, than they would to full colour.

Following the tradition of Samuel Bourne and Auguste Bisson, Adams is perhaps the last of the great mountain photographers. He insists, however, that his work goes beyond the mere documentation of the physical features of the land, no matter how dramatic his photographs may appear. In spite of the fact that one associates his work with a superb command of the technique of photography, he works with only two or three cameras and lenses, in the belief that limitation breeds expertise. He has also said that what the photographer sees, and the way he reports what he has seen, is of far greater importance than the possession of mechanical equipment. He is an ardent conservationist who uses the medium of photography to make us more aware to the fact that the remaining tracts of land, which as yet remain undeveloped, are extremely vulnerable.

Adams was once asked why there are so few people in his photographs, to which he responded

by saying that there are always at least two people present in every image: the photographer and the spectator.

In 1932, together with Edward Weston, Imogen Cunningham and others, he founded the Group

f64 which was dedicated to straight photography. Although the group existed for only a short time, Adams has nonetheless since adhered to the main principle of confronting a scene straightforwardly, without unnecessary distortions or camera trick- ery. He has published numerous folios of his work, usually in series related to a theme, and his manuals of technique have become standard works for students of photography throughout the world.

John Blakemore

'The process of making photographs is rooted in reality, in the photographer's response to his feelings about the physical world. To work with a medium is to accept and to exploit its limitations; the fundamental limitation of photography, and to me its greatest strength, is this need for connection, for subject. One must take a photograph of something, the camera must be pointed away from the photographer, the self, towards the world. Involvement with subject, intensity of experience, of seeing, is for me, the basis of meaningful photography. The camera becomes a link, a means of concentration of communion.

'For me the work process consists in the development, the refinement of this response, this moment of recognition, an intensification of awareness through intimate relationship with the areas in which I photograph. In a way, we all learn to recognize our own, our personal "landscapes" which we construct out of our needs, preoccupations and obsessions. The areas of the landscape in which I work are narrowly defined, a stretch of beach, a length of river valley, a wooded hillside. Areas which in some way speak to me and which I explore again and again, to learn to see, to allow the possibility of understanding, of communion. To be in the landscape, to experience it with intensity, with intimacy, is to feel awe, awe at the power, the fecundity, the sheer, exuberant vitality of nature. So that the act of photography, the attempt to communicate this response, this complexity, seems at times an impossibility, an act of presumption. Perhaps paradoxically though, my photography is built around this ritual of intimacy with place. I do not see my photographs as being concerned with place in a physical or geographical sense. The photograph may provide an intense description of reality, yet the camera also transforms what it sees. What I seek to evoke in my photographs is the dynamic, the physical and spiritual energy of nature, as manifest in the landscape. To produce images which function both as fact and as metaphor, reflecting both the external world, and my own inner response to and connection with it.'

Ansel Adams *Previous page:* Moonrise at Hernandez, New Mexico. This photograph was taken in 1944 when Adams was driving towards Santa Fe at dusk. He realized that he had very little time to set up his equipment and make an exposure before the sun would disappear. In the few minutes left before darkness there was just enough light to record the main features of the church and cemetry, and also register some detail of the snow-capped mountains of the Sangre de Cristo range beneath a full moon.

John Blakemore: Rock Pool, Friog, north Wales

Gianni Berengo Gardin

Gianni Berengo Gardin made his first tentative contact with photography in 1954, when he joined a photographic group in Venice. Like most beginners, he says that he went through a brief period of 'obligatory eclecticism' – testing all the current trends in photographic technique. Later he formed his own group with a few friends who shared his ideas, it was called 'Il Ponte' – The Bridge. Their work was widely exhibited and reproduced in various journals and magazines throughout the world.

Though he never went out of his way to seek recognition, Gianni Berengo Gardin became widely respected as a photo-journalist, producing work for numerous international magazines, including, *Time, Stern, Réalitiés, Vogue* and *L'Espresso*. He also worked with Henri Cartier-Bresson on a commission for Olivetti. In his reportage work he says that he was attempting to use the medium of photography as a social probe – producing narrative images which were poignant comments on the social and religious systems of various countries.

Bernard Berenson once said that no artifact is a work of art if it does not help to humanize us. Berengo Gardin's photographs of Tuscany are more than mere factual records of the physical features of that region – they are images which feed the spirit. For many people the landscape of Tuscany represents the classical ideal – with all the Virgilian constituents of terraces of vine and olive, and the distinctive shape of the cypress tree. And yet, surprisingly perhaps, there have been few photographers who have been able to convey the sense of atmosphere which is pellucid and intense. It is a landscape which is essentially monochromatic – the colour diffused by the luminous haze which separates each successive plane. Although he lives in Milan, Berengo Gardin has a predilection for the landscape of Tuscany, and his response to that region is unashamedly emotional.

Gianni Berengo Gardin: Landscape at Tuscany.

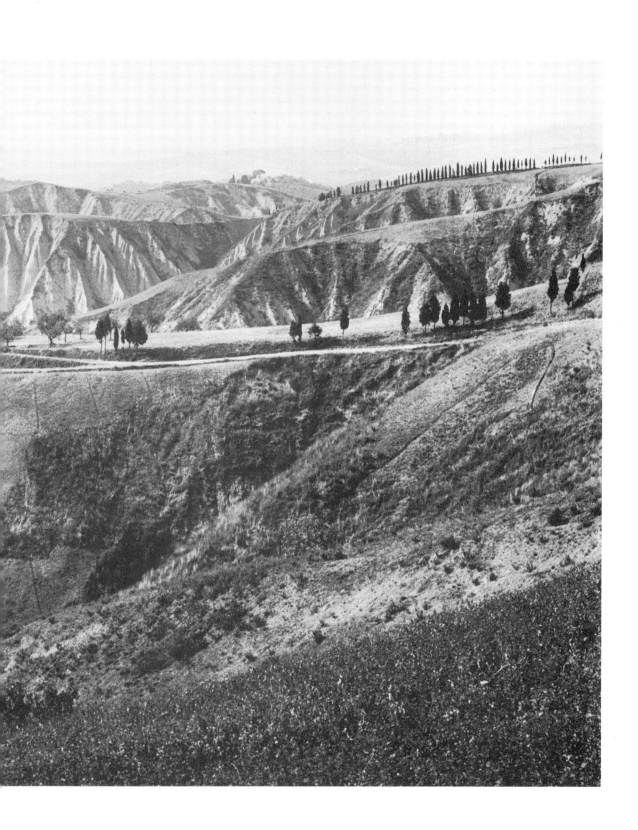

Mario Giacomelli

A landscape photograph taken by Mario Giacomelli can make such an instant impression, that even long afterwards when one has become more familiar with the wider range of his work, nothing persists more clearly in the mind than that first moment of revelation.

The rumpled hills and mountains of Italy account for four-fifths of the total land mass; leaving precious little land for cultivation. In the predominantly hilly regions of Tuscany, Umbria and more particularly the district of Lorma, where many of Giacomelli's photographs were taken, the arable farmer must necessarily sow his crop in small tracts of land disposed at different levels on hills which are craggy and seemingly inaccessible. When the crop has been harvested, the pencil-sharp patterns of alternating lines of stubble and furrow provide a visual link from one field to another, producing the continuous tremulous rhythms which interest Giacomelli. He is concerned with revealing to us a landscape that is vibrant and alive, rather than a dormant patch of vegetation. These contour lines which straddle the rugged undulations of the hillside are transitory, disappearing as soon as the winter ploughing begins. Giacomelli must therefore work during that brief pause between the end of harvesting and the next phase of the farmer's work-cycle.

Giacomelli is known as a painter and poet, as well as being one of Italy's most important photographers. He did not in fact take up photography until he was 29. His subject matter is not limited to landscape; he has produced numerous photographs which are incisive comments on social problems in Italy. One of his most disturbing series on the theme of old age he called, 'Death will come and will have your eyes.' He has said that he would like to enter the souls of men through the medium of photography, in the hope that by digging among the roots of memories, he will discover something of lasting value.

The landscape photographs by Giacomelli do not belong to the tradition of straight photography, nor does his work reflect the influence of any 'school' of photography. The images he produces owe more to the Post-Impressionist painters and to the surrealists. He is attempting to transform reality, rather than merely record it – even though he must depict the real world in his photographs. He will use whatever techniques are at his disposal to produce an image which he

believes to be entirely new. 'Photography not only teaches us to see, but also to "be." It makes us what we are.'

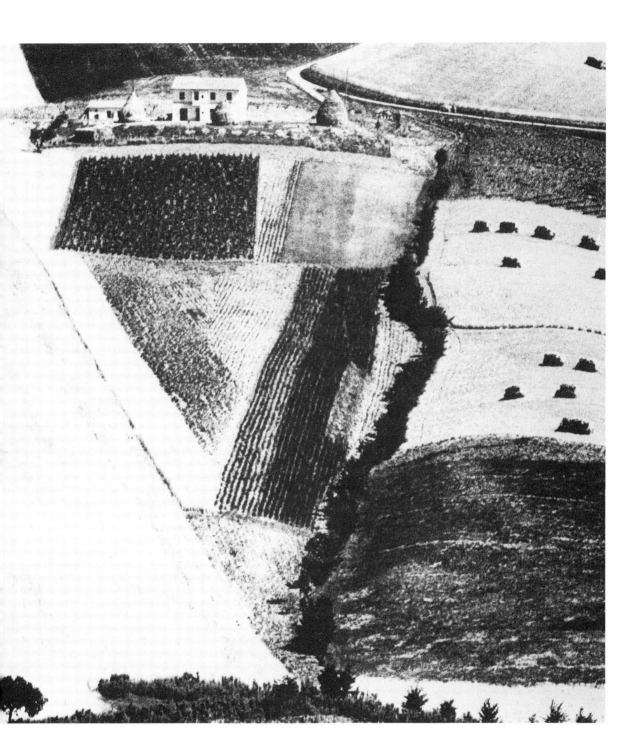

Mario Giacomelli: 'June.'

Aart Klein

This view of the wall surrounding the town of Hulst in Holland seems almost effortlessly composed. It is a superb example of handling a mirror-image – one of the most difficult of landscape subjects. Here Klein has photographed his subject under just the right conditions of light, at a time when the river was absolutely still, and from a carefully selected viewpoint. He provides just enough information to induce a sense of mystery and anticipation. The atmospheric qualities and the general mood of the composition are governed by his skilful tonal control.

In talking about his own approach to photography, Klein puts forward the idea that one should think in terms of white on black (or grey). He says, for example, that if one were to take a photograph in a totally dark room, the resulting print would be absolutely black. Whereas if there were some light falling on an object in the room, then the print would reveal white areas on the parts that were previously black. All of which he says contrasts with the idea of making marks on paper with a pencil. 'Look at a zebra and see that it is not a white horse with black streaks, but a black one with white steaks.'

It is interesting for us to consider how this concept of 'white on black' relates to Klein's photograph of Hulst; is it a black on a white image, or white on black?

Klein says that his own photographs are concerned with small fragments of reality. He believes that while special lenses such as a wide-angle or fish-eye enable one to record a great deal of information, the more detail one tries to include, the less one is able to distinguish the main features of the composition. He recalls how the American astronauts took a remarkable photograph of the Earth with a Hasselblad camera. The photograph shows the Earth as a beautiful coloured ball in space. 'At the moment that the photograph was taken, there was a war going on somewhere, a revolution, a football match, a horserace, half the population were sleeping, some were dying, some were being born, some were ploughing through the snow, as others were sun-bathing' – we know this, says Klein, 'but the photograph taken by the astronauts does not reveal any of this activity.' If one wants to photograph such events, one has to get much closer to the subject. The details that the photographer selects are his own, seen and visualized by him alone, and are uniquely recorded on film.

Aart Klein: Wall around the town of Hulst.

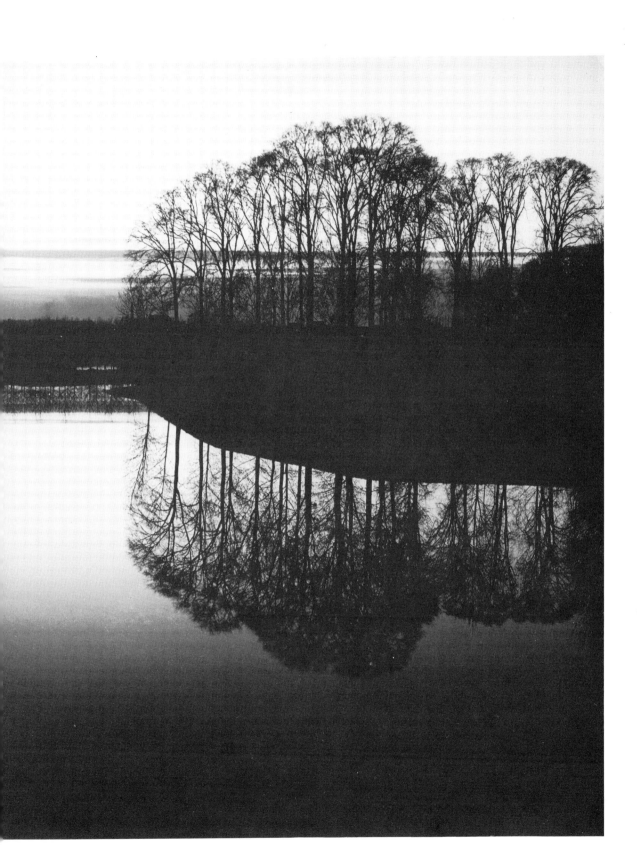

Raymond Moore

In discussing the work of individual photographers, one is always conscious of the fact that too much verbal description can dissipate the essential visual qualities of the image. For this reason Raymond Moore prefers to allow the image to stand on its own without any lengthy written commentary. Valéry said that the poet is one to whom the difficulty of writing verse gives ideas, and, although Moore may find it difficult or even unnecessary to talk about his work at length, when he does comment on any of the photographs he has produced, he usually puts forward ideas which are of intrinsic value.

Referring to 'Wallscape and Sky,' he says that the idea of a wall with landscape overtones has always intrigued him – 'it seems to evoke a sort of bridge between the natural and the man-made: what exactly do we mean by landscape anyway?' He recalls that in listening to some music by Edmund Rubbra called 'Inscape,' which relates to a poem by Gerard Manley Hopkins, the sense of an inner landscape became more important. 'The

camera's way of "distorting" "reality," is somehow all part of this; something happens that sometimes works in your favour, sometimes not – mostly the latter I'm afraid!'

The landscape photographs produced by Raymond Moore sometimes work on different levels. In 'Wallscape and Sky,' for example, there is a disturbing relationship between the opposing perspective of the primary elements in the composition and the absence of any reference to the human scale. At the same time, the surface markings on the wall, and the texture of the wall itself, are equally compelling.

His work bears the imprint of an acute awareness and sensitivity to purely visual phenomena, and, although his images are carefully composed, the content is in itself so compelling that one is totally unaware of any conscious effort on his part to produce a beautifully composed photograph. He once described photography as a means of sifting or abstracting visual phenomena, and all his photographs hint at the extensive process of selec-

tion that has taken place. Moore works within self-imposed constraints which many photographers would find too daunting. He prefers to work with equipment which can be conveniently carried around, and will use any camera which will render sufficient quality of image without being burdensome. Like most truly creative photographers, he believes that technique should be subordinate to the idea, rather than being an end in itself.

Although he may have a predilection for particular locations – the west coast of England and Wales for example, the aspects of landscape which are of interest to him could be rediscovered elsewhere, since the qualitites which arouse his interest come partly from within the photographer himself – 'in photographing a fraction of the subject's life, the photographer reveals his own.' Note: The subtle tones in a print such as 'Wallscape and sky' are levelled out to a certain extent in reproduction. One should therefore always make the effort to see original prints whenever they are exhibited.

Raymond Moore:
'Wallscape and Sky,' Maryport, Cumbria.

155

Emile van Moerkerken

There are approximately 1000 people per square mile in Holland, making it one of the most densely populated countries in the world. Aside from the vast industrial areas, however, the more characteristic landscape of flower fields, canals, dykes and windmills, is still very much in evidence. Although it is only one-sixth the size of Great Britain, large tracts of land are continually being reclaimed from the sea. It is in these areas that Emile van Moerkerken has produced some of his most interesting photographs. He has also produced a film of Wadden-walking, the custom of walking across the Waddenzee at low tide to the islands. His subject matter is not contained by the boundaries of his native country, however; he has travelled widely throughout Europe, the Middle East and the USA.

In his landscape photographs he says that he is trying to establish what he calls a foreground-background relationship, and this is demonstrated here (see also no. 73). In this photograph there is a certain ambiguity about the conspicuous white shape in the foreground, which counteracts the more tranquil backdrop of lakes and mountains.

Emile van Moerkerken: Scotland.

Guy Ryecart

Photographic students are today constantly assailed by a surfeit of ideas and imagery which is disseminated through exhibitions, seminars, documentary film, books, magazines and so on – they will emerge from a course of study feeling either stimulated or extremely confused.

Guy Ryecart is one of the more interesting landscape photographers to come out of the English art school system in recent years. He was fortunate to have selected a course where the instruction provided was not too dogmatic, and where he was allowed to pursue his own ideas tempered by sound advice from his tutor. The discipline he imposed on himself was in fact far more rigorous than that which might have been imposed by a more conventional school of photography.

He would readily admit to being influenced by Weston, Minor White and Wynn Bullock, though he has never consciously tried to emulate the West Coast school or their methods of working. In 1974, he spent ten days working on the Aran Islands off the west coast of Ireland. Finding himself contained temporarily within the boundaries of a comparatively small island, and being an outsider in the midst of a closed community, the distractions were few, and there was little else to do but concentrate on his work. The images he brought back to the mainland were remarkable for their atmospheric qualities, and for the feeling conveyed of a place shaped by the blustery ferment of Atlantic squalls. In his printing technique he demonstrates considerable skill in producing a tonal balance which will eliminate unnecessary detail, and concentrate the main sources of light on the focal point of the composition.

Guy Ryecart:　Aran Islands.

Denis Thorpe

As a working journalist, Denis Thorpe usually takes photographs in response to a specific assignment. He must also work within the constraints of the newspaper deadline. In general, however, he feels that this kind of discipline makes for a more incisive use of the medium, since one rarely gets the opportunity of taking the photograph a second time.

Whether his subject matter deals with people, everyday events, or landscape, he approaches each task with an open mind, relying on intuition rather than on any preconceived notion of how the photograph should be composed, etc. In fact, he has learned from experience that whenever one tries to work with a particular plan in mind, the results are often disappointing.

While he was doing two years' military service, he spent much of his free time indulging in the gentle art of 'just looking,' in whatever part of the country he happened to be posted. The expense of acquiring a camera and the necessary photographic equipment was in any case beyond his means. Nevertheless he says that his interest in photography really stems from that period of his life when he began to evaluate his visual experiences, and to ask himself why it was that he felt stimulated more by one place than another. When he is on a newspaper assignment, Denis Thorpe often works with a writer. Landscape subjects on the other hand he feels should be handled in isolation – 'This for me is a pretty lonely pursuit, mainly because you have to be patient, and unless you have a companion who is completely sympathetic and on the same wavelength, you can be tempted to give up easily.'

The photograph of Hebden Bridge was taken on a day of grey skies and after a heavy fall of snow. He was already familiar with the main features of the town, and he knew that the snow would have the effect of linking the terraces together in an interesting way. When he arrived on the scene, however, the light was too even. He felt that he needed just a little brighter light from the west to animate the composition. He had to wait four hours in freezing

conditions until the cloud broke sufficiently to allow enough light to filter through to the terraces. A few seconds of weak evening sunlight was all that was needed to transform an otherwise dull view of a Yorkshire milltown into a scene which is curiously reminiscent of Flemish landscape painting of the sixteenth century.

Back in the darkroom, only one frame of the sequence he took gave the image he had hoped to get. He finds it essential that the photographer alone should make the print; unless of course one has the assistance of a master technician who can follow instructions precisely. 'How on earth can anyone else, however skilled, know exactly how I have seen a subject?'

Denis Thorpe has no fixed ideas about composition but feels that one needs a kind of hypersensitive awareness – 'There seems to be no secret – just the pursuit of personal instincts, and if others like what *you* see, then that really is satisfaction.'

Denis Thorpe: Hebden Bridge under snow, 1978.

Index